From *Celluloid* to *Cyberspace*

The Media Arts and the Changing Arts World

Kevin F. McCarthy
Elizabeth Heneghan Ond

D1411875

RAND

Supported by The Rockefeller Foundation

The research in this report was supported by The Rockefeller Foundation.

Library of Congress Cataloging-in-Publication Data

McCarthy, Kevin F., 1945–
 From celluloid to cyberspace : the media arts and the changing arts world /
Kevin F. McCarthy, Elizabeth Heneghan Ondaatje.
 p. cm.
 "MR-1552."
 Includes bibliographical references.
 ISBN 0-8330-3076-0
 1. Experimental films. 2. Experimental videos. 3. Video art. I. Ondaatje,
Elizabeth Heneghan. II.Title.

PN1995.9.E96 M38 2002
791.43'3—dc21

 2002031706

Cover design by Eileen Delson La Russo

Published 2002 by RAND
1700 Main Street, P.O. Box 2138, Santa Monica, CA 90407-2138
1200 South Hayes Street, Arlington, VA 22202-5050
201 North Craig Street, Suite 202, Pittsburgh, PA 15213-1516
RAND URL: http://www.rand.org/
To order RAND documents or to obtain additional information,
contact Distribution Services: Telephone: (310) 451-7002;
Fax: (310) 451-6915; Email: order@rand.org

This is the second in a series of reports that examines the state of the arts in America at the beginning of the 21st century. As in our earlier report on the performing arts, *The Performing Arts in a New Era* (MR-1367-PCT, 2001), this study uses a systemwide approach to examine the media arts in the context of the broader arts environment and to identify the major challenges they face. This approach focuses on the organizational features of the media arts by describing the characteristics of their audiences, artists, arts organizations, and funders.

In contrast to the performing and visual arts, the media arts—defined as art that is produced using or combining film, video, and computers—only emerged during the past century and have placed a special premium on experimentation and the use of technology. This report briefly summarizes the development of the media arts, how the different art forms within the genre compare, and the challenges the media arts face.

The report should be of interest both to the media arts community (artists, organizations, and funders) and to individuals interested in arts policy and the future of the arts in America. We hope it not only provides useful information about broad developments in the media arts but also promotes analysis of the media arts more generally.

The research in this study was supported by a grant from the Creativity & Culture program at the Rockefeller Foundation.

CONTENTS

The arts in America are entering a new era that will pose an array of challenges for the arts community. The key to developing strategies to respond to these challenges is to understand how and why they are occurring. However, our current knowledge of the operation of the arts world and its underlying dynamics is limited.

These limits are particularly pronounced with regard to the newest and most dynamic component of the arts world: the media arts. Defined as art that is produced using or combining film, video, and computers, the media arts encompass a diverse array of artistic work that includes narrative, documentary, and experimental films; videos and digital products; and installation art using media. The media arts differ from the more traditional performing, visual, and literary arts in several respects. First, they lack the long history, well-established traditions, and external visibility of other art forms. Second, they place a premium on innovation and experimentation. Third, their creation and distribution rely to a much greater extent on emerging information technologies.

These features of the media arts make them particularly worthy of study both in their own right and for the insights they may offer into the future challenges facing the arts. This report examines the organizational features of the media arts, places them in the context of the broader arts environment, and identifies the major challenges they face.

Our analysis indicates that media artists and arts organizations face many of the same challenges that confront the arts world more generally: adapting to changing patterns of audience demand, making an adequate living in an increasingly competitive employment environment, adjusting to changes in the system of distribution of the arts, and securing financial resources in a more challenging funding environment.

Unlike the more traditional arts, however, the media arts bring a different set of assets and liabilities to bear in dealing with these challenges. Consistent with their youth, the media arts abound with artistic vitality, a spirit of innovation, a

history of social activism, and far more aggressive use of new technology. Consistent with their internal focus, on the other hand, the media arts lack external visibility, a clear sense of self-identity, and an explicit understanding of their relationship to the wider society. If the media arts are to build on their special assets in the changing environment of the future, they will need to address these liabilities.

THE CHANGING ARTS ENVIRONMENT

The past 50 years have been a period of unprecedented change for the arts in America. The arts world emerged from World War II sharply divided into nonprofit and commercial sectors. The nonprofit sector, which concentrated on the live performing arts and the display of visual arts in museums, was dominated by a few elite institutions centered in major metropolitan areas, catering to largely affluent, white audiences, and supported by a few major patrons of the arts. The commercial arts, on the other hand, which were largely concentrated in the recorded arts (film and music) and commercial publishing, provided popular entertainment to much larger and more diversified audiences.

The nonprofit sector grew dramatically over the next 30 years as a series of initiatives spawned an order of magnitude growth in the number and diversity of nonprofit arts institutions, audiences, artists, and funding. The commercial sector flourished as well by providing a growing variety of popular products to expanding national and international markets. Continued technological advances increased the sophistication and range of products produced and the complexity of means through which they were delivered.

Recently, a new series of developments indicates that the arts world is shifting again. Both the nonprofit and commercial arts, for example, face increasing competition for their audiences. This change is affecting the public's inclination to participate in the arts as well as what they consume and how. Helped by rising incomes, changing lifestyles, and a leisure industry committed to providing attractive options to a growing market, Americans have a wider array of leisure-time options than ever before but less free time to exercise those options. As a result, the ways in which Americans participate in the arts have been changing: Attendance at live performances has stabilized, an increasing fraction of people participate through the media, and consumers are increasingly favoring art forms and modes of participation that allow them to determine what they consume, when, where, and how.

Despite the continuing difficulties that artists face in making a living from their art, the number and diversity of individuals who identify themselves as artists have been increasing. The role that artists are playing and the settings in which they work also appear to be broadening. As a result, both amateur and profes-

sional artists are playing increasingly important roles in supplying arts to the American public.

The commercial and nonprofit sectors also face increasing financial pressure—although for different reasons. In the commercial sector, both the risks and potential rewards from projects are soaring. Despite enormous payoffs from blockbuster hits, fewer projects earn enough to cover their production, marketing, and distribution costs. And after a decades-long expansion, the nonprofit sector also faces new financial pressures. These pressures are products of declining levels and shifting sources of government funding and the increasing practice of corporations and foundations to target their contributions. In response, the nonprofit arts sector has been driven to increase its earned revenues.

In combination, these developments are reshaping the organizational ecology of the arts world and blurring the traditional distinctions among sectors, disciplines, and media. Instead of a sharp demarcation between a nonprofit sector producing the high arts and a for-profit sector producing mass entertainment, the arts world appears to be increasingly divided along the lines of small versus large organizations and those that cater to broad markets versus niche markets. Large organizations—both commercial and nonprofit—rely increasingly on marketing campaigns and celebrity artists to attract the largest possible audiences and provide the greatest opportunities for associated marketing revenues. Small arts organizations, on the other hand, are becoming both more dynamic and more diverse and are targeting niche and specialized markets.

Technology has played an important role in this process by spawning entirely new art forms and reshaping how the arts are distributed. But these may only be the most obvious of technology's effects on the arts. In addition, technology is also affecting the size and character of the audience for the arts, how individuals experience the arts, the motivations and practices of artists, and even the social purposes of the arts.

THE DEVELOPMENT OF THE MEDIA ARTS

These technological developments are particularly apparent in the media arts, which spring from technologies that have developed largely during the past century. Throughout their brief history, the media arts have continually applied and adapted new technologies for a variety of artistic purposes including storytelling (narrative), providing insight into the world as it exists (documentary), and offering new perspective for our perceptions of time, space, and motion as well as exploring the properties of these tools (experimental work). The specific styles used within these traditions have changed, however, as media artists have

adopted different technological tools (film, video, and, most recently, the computer) for their artistic purposes.

Not surprisingly, given the focus of the media arts on artistic practice and innovation, those in the field have devoted relatively little attention to such structural features as the size and characteristics of their audiences; the employment and background characteristics of media artists; the number and types of organizations that fund, produce, and distribute the media arts; and those features of the media arts that identify them as a distinctive arts genre. Thus, the growing literature on the media arts discusses aesthetics, interest in social commentary and change, artistic styles, and techniques but contains very little empirical information on structural features. Although this situation is understandable, it poses a real challenge for building a comprehensive assessment of the structural features of the media arts and how they compare with those of the performing, visual, and literary arts.

STRUCTURAL FEATURES OF THE MEDIA ARTS

Audiences

Gaining access to wider audiences has been an ongoing objective of those in the media arts and one they have often struggled to achieve. This situation may well be changing since the media arts seem better positioned than other art forms to pursue opportunities afforded by the changing arts environment. The public's increasing reliance on the media and increasing familiarity with computers, for example, are well suited to the media arts. Similarly, improvements in reproduction and transmission technologies that enable individuals to enjoy the kinds of art that they want, when and where they want, should also benefit the media arts. Indeed, the growing importance of broadband technology and the Internet in the production and distribution of the arts, the opening up of new markets for work that had largely been abandoned by traditional distributors (e.g., short films), and the possibility of direct exchanges between artists and their audiences should all provide consumers with better access to the media arts.

How these developments will affect the specific media arts may in part depend upon how various intermediaries, e.g., distributors and critics, view the breadth of their market appeal. Of the three categories of media art, narrative work appears to have the broadest appeal—judging by the fact that almost two-thirds of all Americans attend films annually and over 90 percent watch television. In contrast, documentary and experimental work, for a variety of reasons, is more likely to benefit from developments that appeal to specialized audiences. The ability of the media arts to take advantage of these opportunities, however, may well depend on the public's getting better information about and access to the

media arts and on the attitudes of those in the media arts community toward commercial success—something about which they have sometimes been ambivalent.

Artists

As is true of the arts in general, the number of media artists has been increasing and their backgrounds have been becoming more diverse. Several developments have contributed to these trends. First, the emergence of computer-based work appears to have attracted a large number of new artists to the field. Second, declining costs of the technology used in the media arts have made work as a media artist more affordable. Third, the growth of university film schools and media arts programs has provided training to a much greater number of potential media artists. Finally, reduction of the traditional barriers to collaboration between the commercial and independent sectors has expanded the employment options of media artists.

Although these developments provide increasing options for media artists, they also raise a series of policy and regulatory issues for the media arts, especially with regard to copyright laws and access to the Internet and other new distribution technologies. They also raise other important questions, such as whether, given the proliferation of new work and new channels for distributing it, media artists will become increasingly dependent upon intermediaries to help overloaded audiences alert them to the voices they want to hear. Finally, if the market for media arts work becomes increasingly driven by economic impulse, how will it affect the content of the media arts, much of whose markets will remain both small and highly specialized?

Organizations

Media artists depend upon a host of intermediaries to help them obtain the resources they need to cover their expenses and produce their work as well as to arrange to have their finished products distributed, exhibited, and marketed. The challenges these processes present are germane to all artists, especially those who are just starting out or whose work is not yet recognized. However, they may be particularly acute for media artists for three reasons. First, media artists often work alone or with groups put together for a specific project and thus may lack the institutional resources available to other types of artists. Second, the market for media arts work is often highly specialized and, given its rapidly changing nature, not well identified or established. Third, the distribution process itself appears to be changing—as festivals for screening new work proliferate, and broadband technology, e-commerce, and digital technology

lower distribution costs and enable commercial firms to enter the market profitably.

Although these developments raise problems for the media arts, they also offer new opportunities. For these opportunities to be realized, however, several issues will need to be resolved. Can effective business models be developed to translate the promise of new distribution technologies into reality? Will the entry of commercial firms into the media arts market affect traditional niche market distributors? And will the new commercial distributors make the investments needed to develop the supply of media arts content?

Funding

The media arts, like the arts more generally, face a new and more challenging funding environment. In this new environment, individual media artists must compete for a shrinking pool of grant funds and may have to rely more on earnings to support their work. Media arts organizations face similar pressures to increase their earned revenues in the face of uncertain public funding and an increasing tendency for corporations and foundations to channel their support for the arts through restricted categorical funding.

These challenges may be particularly troublesome for media arts for several reasons. First, government funding for the media arts, particularly National Endowment for the Arts (NEA) funding, has declined sharply. Although small arts organizations (which most media arts organizations are) never received the lion's share of government funding, they have traditionally been more heavily dependent upon government funds. Second, local government and corporation funding for the arts appears to have favored larger organizations over smaller ones—a pattern that puts media arts organizations at a disadvantage. Third, individual contributions, now the largest single source of arts funding, are often tied to developing a sense of community among contributors—and the media arts field appears to lack basic information about its audiences. Finally, increasing attention by public and private funders alike has been focused on the public benefits of the arts and how their contributions can advance those benefits.

CHALLENGES FACING THE MEDIA ARTS

Although we cannot draw a definitive picture of the status of the media arts today without better empirical data, our analysis highlights the artistic vitality of the media arts, just as it underscores their lack of a clear sense of identity and external visibility. In addition, it identifies a series of challenges that the media arts face. These challenges fall into five areas: distribution, funding, under-

standing the public benefits of the arts, preservation, and developing a clearer identity and greater visibility for the art form.

As our discussion of organizational structure makes clear, several policy issues concerning the distribution of the media arts need to be addressed before the promise of changes in this area can be realized. These include questions about copyright regulations, determining artists' share of revenues from their work, developing business models for the new distribution channels, and developing strategies for the distribution of the new interactive media. The challenge for the media arts community is to ensure that it has a voice in how these issues are resolved.

The media arts also face a more demanding funding environment. Securing adequate funding appears to have become more difficult in part because of declining funding levels (e.g., NEA grants) and in part because traditional funders have changed their criteria for allocating funds. The challenge for those in the media arts is both to increase funding levels and to diversify their funding sources. Although increasing earnings may help alleviate this problem, it will not solve it because, given the nature of their work, many media artists and the organizations that support them must continue to rely on various forms of contribution and grant income.

In recent years, increasing public concern has been expressed about how the arts in America advance the public interest. This concern is shared both by arts policymakers and by public and private funders. Although segments of the media arts community have at various times echoed this concern, it has not engaged the field as a whole. The challenge is to identify explicitly and document the public benefits of the media arts.

Another challenge facing the media arts concerns preservation and technological obsolescence. Given the importance of experimentation in the media arts and their rapid adoption of technological innovation, they, unlike the other arts, face a major issue of how to preserve works using formats, equipment, and computer code that may no longer be available.

Finally, although the public is certainly familiar with film, video, and computers (the basic tools of media artists), it is not clear that people understand how media artists differ from their counterparts who work with these media. Indeed, judging from the literature and our discussions with individuals in the media arts field, there appear to be disputes among media artists themselves on how to define and describe their field. Without a sense of the media arts as a distinctive genre, funders may be less likely to provide programs for the media arts and the public will be less aware of the media arts both as consumers and as potential contributors. The challenge for people in the media arts is to develop both a clearer identity of and visibility for their field.

RECOMMENDATIONS

In light of these challenges, we conclude with a set of recommendations. First, the media arts community needs to develop a clearer sense of identity and greater public visibility for the media arts. Second, it needs to be more attuned and responsive to the policy context in which it operates. Third, it needs to address the lack of systematic information about the field as a whole—including its audiences, artists, organizations, and funding. Finally, both media artists and organizations need to become more active in building greater public involvement in their work.

ACKNOWLEDGMENTS

This work was initiated and inspired by Joan Shigekawa, Associate Director of the Creativity & Culture program at the Rockefeller Foundation. We are especially grateful for her encouragement and patience throughout the course of this research. We extend our thanks to the dozens of members of the media arts community who shared their ideas with us and added immeasurably to the report. Special thanks are due to John Hanhardt and Lev Manovich for their thoughtful reviews, which occasioned many changes that improved the clarity and accuracy of the report. We also thank our RAND colleagues Lisa Lewis, Judy Rohloff, Miriam Polon, Eileen La Russo, and Denise Constantine.

INTRODUCTION

Recent studies have called attention to emerging shifts in America's arts environment and the challenges they are likely to pose for the arts world (McCarthy et al., 2001; Cherbo and Wyszomirski, 2000; Balfe and Peters, 2000; American Assembly, 1997). Pointing to such developments as changing patterns of consumer demand, increasing diversity of artistic forms and artists' roles, the diffusion of new distribution technologies, increasing collaboration between the commercial and nonprofit arts sectors, and changing funding patterns, these studies argue that the arts in America are entering a new era. The key features of this new era include: a more complex organizational structure in which traditional distinctions between commercial and nonprofit organizations will blur; more emphasis on earned revenues than on public subsidies; and more attention to the role of the arts in society and the public benefits the arts provide. When combined with the financial pressures the arts sector has traditionally faced (Baumol and Bowen, 1966), adjusting to this new environment seems certain to pose a challenge for artists, arts organizations, and arts policymakers.

The key to developing strategies to meet these challenges is to understand the source and nature of the changes engendering them. Our ability to do so, however, is limited by current gaps in our knowledge. We know, for example, how these changes are affecting some art forms, such as the performing arts, much more than others. Similarly, although we recognize that a host of social, economic, political, and, in particular, technological forces have produced these changes, we do not know how those forces operate. Without a better understanding of how these changes are being manifest in different art forms or the dynamics that drive them, arts organizations and policymakers will find it difficult to develop successful strategies to respond to them.

These gaps in our knowledge are particularly glaring with regard to the media arts. Springing from technologies (film, video, and computers) that largely developed during the last century, the media arts are both very new and particularly dynamic. The media arts—defined as art that is produced using some combination of these technologies or incorporating media objects as an essen-

tial component of their work—include a diverse array of artistic work. They encompass narrative, documentary, and experimental films; videos and digital products (or work made using some combination of these tools); and installation art that uses media and computer-generated and displayed art.[1]

The media arts differ from other art forms in several important respects. First, the media arts lack the long history, well-established traditions, and external visibility of other art forms. Indeed, when compared with the other arts, the media arts are still in their infancy.[2] Film, the oldest of the media arts, only emerged as an art form at the beginning of the 20th century. Video was not used extensively as an artistic medium until the 1960s, and computers were not adopted for artistic purposes on a significant scale until the 1980s. In contrast, the performing, visual, and literary arts have been in existence for centuries.

Second, the media arts have traditionally emphasized innovation and experimentation. This feature of the media arts is reflected in the strong avant-garde or experimental tradition that has characterized the media arts since their inception. Much of the early film work, for example, was driven by visual artists experimenting with the new medium of film and by early film pioneers whose innovations in their use of the technology and in artistic technique were central to the later development of the medium (Manovich, 2001a). This experimental tradition continued with video artists like Nam June Paik, and later with a host of artists using the computer to develop interactive art.

Third, since their inception, the media arts have relied on technology for their creation and distribution to a much greater extent than other art forms have. This close relationship between the media arts and technology has spawned new art forms and distribution mechanisms within the media arts and also, as Benjamin (1986) pointed out, "transforms the nature of the art itself." In combination, these distinctive features make the media arts worthy of study not only in themselves but also in comparison with the other arts. Indeed, given the influence technology and the new media are having on the arts more generally, understanding how the media arts respond to the challenges posed by the new

[1]In its 2001–2002 strategic plan, the National Alliance for Media Arts and Culture (NAMAC) defines the media arts as including film, video, audio, intermedia, and multimedia. Our definition is similar, although it generally excludes audio (largely music) from the media arts. As one of our reviewers noted, whether to include music among the media arts is a complex question. Certainly, specific forms of contemporary music, especially electronic music, might be included. But music is generally considered one of the performing arts. For example, our treatment of the performing arts (McCarthy et al., 2001) included music within that category. While we recognize that excluding music from the media arts may in some cases be problematic, it is in accord with the general treatment of music as one of the performing arts.

[2]In its most recent strategic plan, NAMAC specifically acknowledges the youth and lack of external visibility of the media arts by recognizing the need to increase the public visibility of the field.

arts environment may provide important insights into the future of the arts in America.

Despite a growing literature on the subject, however, our knowledge of the media arts is incomplete at best. Considered as a whole, the literature on the media arts has several distinct features. First, it is much more likely to focus on individual media arts disciplines, such as documentaries or Internet art, than on the media arts as a distinctive genre.[3] Second, this literature emphasizes the artistic and aesthetic aspects of the media arts rather than their organizational characteristics. Third, there are few systematic empirical data on such features of the media arts as the size and characteristics of their audiences, the employment and background characteristics of media artists, and the number and features of organizations that produce, distribute, and fund the media arts.[4] Finally, the literature on the media arts might generally be described as "fugitive" in the sense that it is scattered across a wide array of sources including newspapers, magazines, academic journals, exhibition catalogues, and online sites that are difficult to find using standard bibliographic sources.[5]

As a result, we lack the knowledge base needed to describe the media arts, to compare them with the other arts, and to identify the particular organizational and policy issues they are likely to face in a changing arts environment. This report is designed to address these topics. Specifically, it aims to establish a benchmark for information about the media arts, to place the media arts in the context of the broader arts environment, and to identify the organizational issues the media arts face and thus the strategic options they might consider in attempting to deal with these issues. Consistent with this objective, we do not discuss in more than cursory form the aesthetic and artistic features of the media arts or how they have changed over time.[6] Rather, we focus on their structural characteristics (such as their audiences or how they are funded, marketed, and distributed), how they compare with other art forms, and what those

[3]As we discuss in a later chapter, this focus on the individual disciplines within the media arts appears to be more characteristic of media arts in the United States than in Europe.

[4]Although fewer empirical data are available for the arts than for other areas, there are several sources—for instance, the Survey of Public Participation in the Arts (SPPA), the Economic and Population Censuses, and IRS Form 99 data—that can be used to describe salient feature of the performing, visual and literary arts. But these sources generally cannot be used to characterize the media arts.

[5]A growing number of journals, magazines, and other sources routinely cover the media arts, e.g., *Millennium Film Journal, Leonardo,* and *Afterimage.* By and large, however, these sources are more likely to focus on aesthetics or critiques than on the organizational or structural issues that are the subject of this report.

[6]Systematic examinations of the relationship among the development of the individual media arts disciplines, changing artistic practices, and the structure of the media arts are still at an early stage in the media arts literature.

features of the media arts as a genre imply for the nature of the organizational challenges the media arts will face in the future.

ANALYTICAL APPROACH

We approached our task from the broadest possible perspective. We wanted to understand how existing information describes the world of the media arts, where the gaps in information are, and how the features of the media arts world might be related to each other.

We employed two sources of information for our analysis: a literature review and interviews and discussions with individuals knowledgeable about the field.[7] First, we reviewed the existing literature. Given the fugitive nature of this literature, we used a complex search strategy that employed a wide variety of sources on the media arts. These sources included literature compiled as part of RAND's Comprehensive Assessment of the Arts, searches of a variety of computer databases on the arts (including books in and out of print, book reviews, items catalogued by the Library of Congress, conference proceedings, and National Endowment for the Arts [NEA] materials), articles in arts and humanities journals, references from other sources, weekly searches of newspapers and periodicals, on-line sources (including on-line exhibits, articles, catalogues, and interviews),[8] and references given to us by individuals we interviewed during the course of our research.

In addition, we interviewed a variety of individuals knowledgeable about the media arts. We identified these individuals in a variety of ways: reviews of the literature, references from other individuals, or meetings involving the media arts. As this description suggests, these interviews were selective and by no means represent a systematic sample of individuals associated with the media arts. Nevertheless, they provided invaluable information for the study.

A central challenge for this analysis was to organize these various sources of information to draw a systematic picture of the media arts. In our previous analysis of the performing arts (McCarthy et al., 2001), we employed an analytical framework that provided us a common structure with which to analyze differences among the organizational features of the performing arts. We employ the same framework here. Unlike most studies of the media arts and

[7]A list of the individuals interviewed during the project is included in Appendix B.

[8]We found this method particularly important because a great deal of growth is occurring in the digital or computer arts, including Internet-based art. Moreover, many participants, artists, and even distributors operate on shoestring budgets and take advantage of the web for low-cost communication. Many communicate primarily by means of the Internet. Finally, some aspects of the media arts emphasize the ephemeral as well as the interactive nature of the art. In this context, the web becomes an especially important part of understanding the field.

their individual disciplines, which emphasize the aesthetic features of the media arts, this framework emphasizes their structural or organizational components.

There are three components to this framework. First, it distinguishes among the different types of media arts. In our performing arts analysis, for example, we distinguished among opera, dance, classical music, jazz, and theater because the audiences, artists, organizational features, and funding profiles of each differ. The media arts, correspondingly, can be distinguished along at least three dimensions:

• disciplines

• the media tools they use

• the functions (narrative, documentary, and experimental) they perform.

For reasons we discuss below, we chose to sort the types of media arts along functional lines, that is, we sort the media arts into narrative, documentary, and experimental works.[9]

Second, our framework identifies the market sector (commercial, nonprofit, and volunteer) in which the art is produced and distributed. When discussing the media arts (as opposed to the performing and visual arts), it is important to note that at least until the 1990s, most treatments of the media arts have excluded work produced in and for the commercial sector. This approach reflected several historical features of the media arts:

• The sharp differences in the production and distribution of film and video work between the nonprofit or independent sector and the commercial or for-profit sector

• The clear and often critical distinction media artists drew between the type and artistic quality of the work produced in the independent and commercial sectors

• The fact that many media artists, unlike their performing and literary counterparts, were unlikely to cross between sectors and were highly critical of those who did. Since the emergence of digital art in the 1990s, however, this distinction has declined in importance—although a distinction continues to be drawn between independent narrative films and those produced by the commercial film studios.

[9]We recognize, of course, that any classification of the media arts we might choose is likely to present analytical problems. Sorting the media arts by function, for example, implicitly assumes that different media arts works fall into only one of these functional categories. Yet the history of the media arts provides abundant examples of work that combines more than one of these functions.

This distinction between the commercial and nonprofit media arts is in some ways ironic. Indeed, when compared with the visual arts, for example, media arts work often begins its life in the nonprofit artistic environment and then crosses over into the commercial sector and vice versa. Consider, for example, the evolution of artistic styles and products within film. Many of the experiments in techniques began as independent artistic innovations but were subsequently adopted by the commercial sector. Similarly, many independent films that were originally thought to have limited audiences were later picked up by commercial distributors and marketed in that sector. Finally, much of the equipment that was originally developed in the nonprofit sector was later transferred to the commercial sector, just as many of the developers of this equipment later marketed it in that sector (Furlong, 1983).[10]

The third component of our analytical framework distinguishes among the various structural components of the media arts system. By *functional components* we mean the various classes of individuals and organizations that serve key functions in the complex process of creating and presenting the media arts:

- audiences
- artists
- arts organizations
- funders.

The process starts with the artist's creation of the work and ends with the audience or user's experience of the work. Between the artists and their audiences lies an array of organizations that present, record, collect, preserve, and transmit works of art. Supporting these organizations are the individuals, foundations, businesses, and government agencies that offer support to nonprofit organizations. Taken together, all these entities make up the media arts system. In combination, this analytical framework allows us to explore the differences and similarities among the media arts and between them and other art forms in a systematic way.

As our description of the literature and the sources we used in this analysis indicates, a major problem confronting our analysis, as well as other studies of the structure and organization of the media arts, is the absence of systematic empirical data. Indeed, one of the principal findings of this study is that more attention should be devoted to the compilation of such data in the future.[11]

[10]We are indebted to Lev Manovich for pointing this out.

[11]The absence of systematic empirical data on the media arts is particularly noteworthy when compared with the data that exist for the performing arts (McCarthy et al., 2001). This point is

Nevertheless, we believe our findings offer some useful insights into the media arts and how their situation differs from those of other genres.

HIGHLIGHTS OF FINDINGS

Media artists and arts organization face the same challenges that confront the arts world more generally in the emerging environment: adapting to changing patterns of demand, making an adequate living in an increasingly competitive employment environment, adjusting to changes in the system of distribution of the arts, and securing support in an era of more challenging funding. However, the media arts share several assets that could make them better able to adjust to these changes than the more established performing, visual, and literary arts. The media arts, for example, are less tradition-bound and have cultivated innovation and experimentation both in arts creation and distribution. They are typically at the cutting edge of new information technologies—perhaps the major force in contemporary culture in what many have referred to as the "new information age."

At the same time, the media arts face a number of liabilities that they must overcome if they are to take full advantage of these assets. In particular, the media arts have tended to focus their energy and attention on the development of artistic practice, the internal challenges they face, and how the external world affects them. As a result, the media arts often lack a clear identity and external visibility.

In many respects, these characteristics are an understandable reflection of the media arts' youth and relatively early stage of development. However, we believe that for the media arts to continue to flourish—as they certainly have artistically—they need to address a series of organizational and policy issues. These issues include establishing a clearer identity as a distinctive art genre, increasing their visibility in the external world, and clarifying both their contributions to the public at large and their role in contemporary culture.

The media arts should recognize and leverage their special assets. All of the arts, for example, face the challenge of adjusting to consumers who increasingly favor art experiences and other leisure activities that allow them to choose what they want to do, when and where they want to do it. This has translated into stable attendance rates at live performances, an increasing propensity to participate in the arts through the media, and the increasing financial viability of

implicitly made in NAMAC's most recent strategic plan, which acknowledges that one of the principal challenges to increasing the external visibility of the media arts is the need to "map the field through data collection." We return to this issue in our recommendations in the concluding chapter.

specialized markets. The media arts have several assets that should position them well to adjust to these changes: a close connection with technologies that enable consumers to tailor participation to individual tastes; a tradition of experimentation and innovation, which has given rise to a diversity of artistic styles and perspectives that appeal to a correspondingly wide array of consumer, public, and research interests; and the specialized nature of the audiences for many of the media arts (both commercial and noncommercial).

For the media arts to leverage these assets, however, they will need better information on their audiences and potential sponsors, how they gain access to the media arts, and whether they understand what the media arts have to offer.

Media artists need to acknowledge and take advantage of new employment opportunities. Similarly, artists—both in the media arts and elsewhere—have traditionally faced problems making a living from their art. These problems seem to have increased as the number of artists continues to grow faster than their employment opportunities. Indeed, as the prices of the technical tools media artists use to create and distribute their work have declined, the barriers to entry have also declined and given rise to what, by all accounts, has been a rapid rise in the number and diversity of media artists. Moreover, increasing demand for media arts content, increasing collaboration between media artists and a variety of commercial and research organizations, and a growing acceptance of the media arts as reflected in the dramatic expansion in the number of media arts training programs, research centers, media arts festivals, and exhibitions offer evidence that the opportunities available for media artists are also expanding. To take full advantage of these opportunities, however, media artists will have to be willing to work in a variety of employment settings, to recognize the diverse range of employment roles available to them, and to reconsider working in the commercial sector.

Media artists need to develop and use their new distribution resources. A central issue for all artists is how to get their work produced, displayed, and distributed. Although they are at the core of the creative process, artists typically do not have a direct relationship with the audience for their work. Instead, they rely on many intermediaries to fund, produce, screen, distribute, collect, preserve, and market their work. The challenges this process poses have often been particularly pronounced for the media arts for two reasons. First, media artists often work as individuals or come together for specific projects and thus lack the institutional resources available, for example, to performing artists. As a result, media artists have often relied on media arts centers, university arts schools, and research centers as intermediaries. But such intermediary organizations face increasing financial pressures because securing institutional support for media arts organizations has been a continuing struggle. However, a promising development within the media arts field has been the emergence of

"broker" organizations, such as Creative Capital and Creative Disturbance, that have helped supply a bridge between the media arts and potential funders and distributors.

A second problem for media artists has been getting their work reviewed and distributed. Ironically, these problems may in fact have intensified as the volume of media arts works has proliferated, because it has become more difficult for any particular artist's work to be recognized. Moreover, the innovative and experimental nature of much of the media arts can compound this problem because both critics and funders may be slow to accept new work and/or lack the expertise to evaluate and present it. These problems may have increased as the distribution system itself has changed. For example, new distribution technologies, such as broadband, the Internet, and e-commerce, have expanded opportunities for direct artist-to-audience interaction and have increased collaboration between the commercial and nonprofit sector. Because the media arts may be better positioned than the other arts to employ these new technologies, they could provide media artists expanded distribution opportunities and access to specialized or niche markets.

Media artists need to address an increasing range of policy issues. For these opportunities to be translated from potential to reality, however, media artists will have to take advantage of them as well as help resolve such policy issues as copyright protections, who will control the Internet (a major new distribution channel), appropriate business models, and the distribution of revenues. For the media arts to play an active role in deciding how these issues are to be resolved, they will need to develop positions on these issues and to be recognized as deserving a voice in the policy discussions about the outcomes. For the media arts to have a central role in these discussions, both the public and policymakers will need to recognize the public benefits the media arts provide and the central role they play in shaping contemporary culture.

Arts organizations should explore new financing strategies. Finally, a critical issue for the arts today is securing financing in a more challenging funding environment. As Baumol and Bowen (1966) pointed out, organizations in the nonprofit arts sector in America have traditionally been forced to supplement their earned revenues with grants and contributions to survive. For several decades starting in the late 1950s, the arts enjoyed substantially increased funding and dramatic expansion. This period of expansion, however, appears to have ended. As a result, art organizations have attempted to increase their earned revenues and to compete for increasingly targeted and limited government, foundation, and corporate funding.

These changes have been particularly difficult for the media arts that have benefited very directly from government and foundation programs. Indeed,

although such funding was only one of many sources, it often proved of vital importance to media artists and organizations. Moreover, the media arts' ability to increase their earnings appears to be more limited than is true of the performing arts, for example. One option is to increase the range of individuals and potential funders who participate in and support their activities. To do this, however, the media arts will need better information on current and potential audiences and funders and how to reach them. They will also need to consider explicitly the strategies they use for involving a wider range of participants in their organizations. Increasingly, the key to succeeding in the new funding environment appears to be tied to the ability of arts organizations to identify how their work benefits the public and supports the development of contemporary culture. Although many of these issues have long been a central concern to the media arts, the media arts community needs to explain and document how it supports such public benefits to advocate for itself in this new environment.

ORGANIZATION OF THE REPORT

The next chapter describes the changing nature of the arts environment in America and the central, if sometimes overlooked, role that technology has played in the arts. Chapter Three discusses the development of the media arts and the concepts used to describe them. Chapter Four applies our framework to an analysis of the media arts to describe the most salient features of their audiences, artists, organizations, and funding. The final chapter summarizes our results, discusses their implications, and offers some recommendations.

THE ARTS ENVIRONMENT IN AMERICA

As we have already indicated, the arts environment in America is changing. In this chapter, we discuss the nature of these changes in greater detail. Although we focus on the shape of change rather than its dynamic, we devote special attention to technology and the role it has played in reshaping the arts environment. There are several reasons for this. First, the role of technology in the arts is often overlooked (Lovejoy, 1992). Second, as we have already noted, we anticipate that technological developments will play an increasing role both in the creation and the distribution of the arts in the future. Finally, because the media arts depend on technology to a much greater extent than do the other arts, we believe that understanding the special character of the media arts will provide insights into the role of technology in the arts more generally.

THE CHANGING SHAPE OF THE ARTS ENVIRONMENT

The past 50 years have been a period of unprecedented change for the arts in America. As it emerged from World War II, the arts world was sharply divided into nonprofit and commercial sectors. The nonprofit sector, focusing on the live performing arts and the display of visual arts in museums, was dominated by a few "elite" institutions centered in major metropolitan areas, catering to a largely affluent white audience, and supported by a few major patrons of the arts. In contrast, the commercial arts, largely concentrated in the recorded arts (film and music) and commercial publishing, provided popular entertainment to much larger and more diversified markets and exercised, at least in the case of the major film studios, considerable control over what the public had access to.

The nonprofit picture changed dramatically during the next 30 years as support, initially from major foundations and later from government and the private sector, spawned an order of magnitude growth in the number and diversity of arts institutions, audiences, and artists, and the emergence of a largely volun-

teer arts sector (Kreidler, 1996).[1] At the same time, new technologies spawned new art disciplines and reshaped traditional art genres. Although the commercial sector's control over the distribution of the recorded arts diminished, this sector continued to flourish by providing a growing variety of popular products to expanding national and increasingly international markets. Continued technological advances increased the sophistication and range of products and the complexity of means through which they were delivered.[2]

During the past decade, however, broad social, economic, and political developments have posed new challenges for both the commercial and nonprofit arts sectors. These challenges are affecting each of the four major components of the arts world:

- the audiences who consume the arts

- the artists who produce the arts

- the various arts organizations that screen, distribute, collect, preserve, and market the arts

- the funders who finance the arts.

Participation Patterns Are Changing

The entire arts world faces a changing pattern of consumer demand. This change is affecting the public's inclination to participate in the arts as well as what they consume and how. Both the commercial and nonprofit arts sectors, for example, face increasing competition for audiences. This competition is a product of the greater variety of individual options for spending free time and of the changing structure of that time. Supported by rising incomes, changing lifestyles, and a leisure industry committed to providing attractive options to a growing market, Americans have a wider array of leisure time options than ever before. At the same time, however, they may have less free time in which to exercise those options. Although it is unclear whether the growth in leisure time that Americans have enjoyed for much of the 20th century has reversed, as some argue (Schor, 1991), there is little question that the structure of that time

[1]The volunteer sector consists of activities carried out by such avocational groups as church choirs and folk arts groups, as well as small nonprofit organizations that may have been formally incorporated as tax-exempt. As discussed in McCarthy et al., 2001, this sector includes much, but not all, of what some arts researchers call the "unincorporated" sector.

[2]The new technologies introduced during this period (and later) include new means of production (video and computer), new recording techniques (tapes, CDs, and, more recently, DVDs), and new distribution mechanisms (VCRs and the Internet). Not only did these and other technologies enable the commercial sector to produce new products and distribute them in more flexible ways, they also contributed to a wide array of developments in the nonprofit sector.

has become increasingly fragmented as a result of irregular work schedules (Vogel, 1998). Leisure activities have also become increasingly home-centered—indeed, Americans spend, on average, three hours of every day watching television (Robinson and Godbey, 1997).

In addition, the ways in which Americans participate in the arts have been changing. Despite the fact that total attendance at live performances and movie theaters has been increasing, the *rate* of attendance (the percentage of the population attending performances) has mostly been stable (McCarthy et al., 2001). Instead, an increasing fraction of Americans participate in the arts through the media, e.g., playing recordings or tuning in to programs on the radio or television. Although at a much lower rate, an increasing fraction of Americans also appear to be participating in the arts directly, for example, by playing an instrument, acting in a play, or painting (NEA, 1998a).

Finally, these changes are affecting what the public chooses to consume. For example, arts consumers seem increasingly to favor art forms and modes of participation that allow them to determine what they consume, when, where, and how—sometimes referred to as "consumption by appointment." Indeed, Americans' desire to personalize their leisure activities, including their arts participation, has been cited as a reason why attendance at art museums, which are open longer hours and have a wider assortment of art from which visitors can choose, has enjoyed larger growth than attendance at the live performing arts (NEA, 1998b). And, when combined with such new distribution channels as the Internet, cable systems, and expanding broadband capacity, these changes seem likely to facilitate the development of a variety of niche and specialized markets as individuals are increasingly able to tailor their consumption to their own tastes, regardless of where they live and what is available in their local markets.

A Portrait of the Artists

In their role as creators and performers, artists are central to the artistic process. Yet we know less about their employment circumstances and career patterns than about those of most other professionals. We do know that the labor market for artists differs from that for other occupations in several respects. First, the demand for artists is uncertain and volatile, so most artists must work outside their profession to make ends meet (Alper et al., 1996; Throsby and Thompson, 1994). Second, although some artists succeed financially, most do not. As a result, there is tremendous variation in artists' earnings, with the rare superstar earning substantial incomes but most artists making little more than minimum wage (McCarthy et al., 2001). Third, most arts organizations do not provide year-round full-time employment. Artists typically work

for multiple employers throughout the course of the year (Ruttenberg et al., 1997–1978). Indeed, many media artists, like visual artists but unlike most performing artists, work on independent projects rather than as employees of established organizations or ensembles.

As a result of these patterns, artists have traditionally had a more difficult time making a living in their profession than other professional employees have. About three-quarters of all artists, for example, are typically employed at least part-time in non-arts jobs (Alper et al., 1996). Moreover, as with athletes, their employment is sporadic; many leave their professions early; and very few make it to the superstar level. Finally, the evidence suggests that their pay and job security have not improved notably for at least the last three decades (McCarthy et al., 2001).

Nonetheless, the number of individuals who identify themselves as artists has been increasing steadily. The range of roles that artists are playing also appears to be increasing—from amateur hobbyists, who practice art as an avocation, to artistic celebrities and superstars, whose incomes far exceed the average for the typical artist. Indeed, amateur and part-time artists appear to outnumber full-time professional artists by a ratio of at least 20 to 1, and this gap appears to be increasing. Finally, both amateurs and part-time professional artists appear to be playing increasingly important roles in supplying arts to the American public (McCarthy et al., 2001).

A More Challenging Funding Environment

Since the emergence of the nonprofit sector around the turn of the 20th century, arts funding in America has primarily followed two different models.[3] The for-profit sector depended upon market earnings, and the nonprofit sector relied on a combination of earnings and contributions. Prior to the dramatic expansion of the nonprofit sector that began in the late 1950s, the bulk of those contributions came from wealthy patrons of the arts (Kreidler, 1996).

That expansion, triggered initially by a Ford Foundation initiative aimed at revitalizing the nonprofit arts sector and using a program of leverage investments that required matching grants, eventually resulted in a host of foundations and corporations becoming active supporters of the arts. By and large, these were unrestricted contributions that gave their beneficiaries considerable flexibility in how the funds were used.

[3]Prior to the 20th century, the performing arts in America were primarily supplied by the commercial sector. For a discussion of the history of the arts prior to that period, see Levine (1988) and Butsch (2000).

By 1960, the public sector—first New York state, then the federal government, and later other state and local governments—had become an active supporter of the arts. Many public programs, especially those initiated by the National Endowment for the Arts, provided direct support to artists. The New York State Council for the Arts and the Rockefeller Foundations, among others, were instrumental in providing initial support to media artists and media arts organizations. These sources were later supplemented by the NEA's media arts program, which made up close to 10 percent of the agency's total grant expenditures in most years.

As the number of new arts organizations grew and with it the population involved in the arts, individual-level contributions and admission receipts rose as well. In sum, the boom period was built on private philanthropy (individual, corporate, and foundation) as well as public support. Earned revenues, which continued to be part of the revenue mix as they always had been, grew along with participation but were not the key to institutional growth.

As our study of the performing arts indicates, however, this funding environment has changed. Although overall levels of support for the arts continue to climb, the composition of that support and the conditions that govern its use have shifted (McCarthy et al., 2001). Public support for the arts, once dominated by federal grants, is now increasingly driven by state and local government funding. By 1999, NEA expenditures, for example, had declined by nearly three-quarters in real terms from their peak in 1976. Since state and local government support is more often designed to further the community-level economic and social benefits of the arts than it is to promote art for art's sake, this trend has meant less direct funding for individual artists and less general support for arts organizations.

Contributions remain a central component of arts organization revenue—and the major reason why total revenue continues to grow—but increasingly they come from individuals whose numbers have increased but whose average gift has declined.[4] Contributions from private foundations and business have also grown, but they are increasingly targeted and their use restricted (Useem, 1990; Cobb, 1996; Renz and Lawrence, 1998). Thus, they provide less flexibility to arts organizations than they have in the past. Earned income has also increased, although its growth is due less to a rise in admissions receipts than it is to an increase in earnings from a host of other ventures such as shops, restaurants, and rental and program fees. Indeed, many nonprofit arts organizations are

[4]This pattern reflects a much broader base of contributors to the arts, but it has also raised concern in the charitable sector as to who will replace the generous individual patrons of the arts as they age. These major donors have traditionally played a major role in supporting the arts (Balfe, 1989).

employing the revenue-enhancing marketing and merchandising techniques of the commercial entertainment sector.

As a result, the literature suggests, funding for artists is fragmented and cobbled together from a range of sources. In addition to support from organizations and government, individual artists appear to rely on gifts and loans from friends and family, in-kind contributions, student and bank loans, personal savings, and earnings from non-arts employment.

New Organizational Complexity

Within the art world, a host of intermediaries intervene between artists and their audiences to make up the arts delivery system. As such, they perform an array of functions and include a wide range of entities: critics who review art; organizations that sponsor, present, produce, collect, and preserve art; and distributors who market and distribute art. In combination, these intermediaries typically determine which art gets presented and how (Caves, 2000; Vogel, 1998). They thus play a critical role in determining not only how the art world operates but also which artists have their work reviewed and distributed (and thus their careers advanced).

Traditionally, the arts delivery systems for the commercial and nonprofit worlds have been distinct—each responding to its own dynamics and each concentrating on somewhat different products. The for-profit sector, for example, specializes in providing the recorded arts and publishing to broad-based popular markets and relies on the earned revenues it collects from these markets. The nonprofit sector, on the other hand, has focused more on live arts and specialized markets and has depended upon a combination of earned and contributed revenues to support its operations. Indeed, as Baumol and Bowen (1966) pointed out in their classic analysis of the economics of the performing arts, nonprofit arts groups face a chronic problem in trying to support themselves in the marketplace and must, as a result, supplement their earned revenues with contributed income to survive. These different dynamics have resulted in distinct marketing and distribution practices in these two sectors.

However, a combination of new financial pressures and developing distribution opportunities appears to be changing these practices. The commercial sector, for example, finds itself facing increasing financial pressures as both the risks and potential rewards from projects soar (Vogel, 1998). Although the payoff from blockbuster hits has become enormous, fewer projects in the commercial sector are earning enough to cover their production, marketing, and distribu-

tion costs.[5] In the face of rapidly evolving technologies and global competition, the shape of the commercial arts world has been undergoing reconstruction as firms merge and enter into joint production agreements. As a result, the number of organizations in the commercial sector has been shrinking as their average size increases (McCarthy et al., 2001). Moreover, in an effort to maximize their earnings and appeal to the broadest popular markets, many of these firms have focused on market-tested themes and stars.

The nonprofit sector is also being subjected to a new set of financial pressures, although the source of these pressures is somewhat different. The decades-long expansion of the nonprofit sector that began in the late 1950s and was triggered by a surge of contributions from foundations, government, corporations, and individuals appears to have ended (McCarthy et al., 2001). Government funding for the arts, for example, has stabilized and has shifted from the federal to the state and local levels. This has produced a corresponding shift from general support for artists and arts organizations to a greater focus on how financial support for the arts can promote instrumental social and economic benefits. Foundation and corporate support for the arts has also become more targeted toward serving the needs of those organizations. Finally, although individual support continues to climb, that support is coming in increasingly smaller average amounts and is increasingly costly to raise. The net effect of these financial shifts has been a growing emphasis within the arts on increasing earned revenues.

In combination, these various developments are reshaping the organizations of the arts world (Urice, 1992; Cherbo and Wyszomirski, 2000). Instead of a sharp demarcation between a nonprofit sector producing the high arts and a for-profit sector producing mass entertainment, the major divisions in the future, as we have suggested elsewhere, will be along the lines of large versus small arts organizations, and those that cater to broad versus niche markets (McCarthy et al., 2001).

Large organizations—both commercial and nonprofit—are relying increasingly on marketing campaigns and celebrity artists to attract large audiences. As a result, the distinctions between popular and high art are eroding as both kinds of organizations seek to produce the next blockbuster. And as the rewards of success and the costs of failure climb, these large organizations will seek to minimize their risks by choosing programming that appeals to the widest possible audience and provides the greatest opportunities for associated marketing revenues.

[5]Nine out of ten commercial recordings, for example, fail to break even. Two-thirds of commercial films lose money, as do 70 percent of all theater productions (Vogel, 1998).

Small arts organizations, on the other hand, are becoming both more dynamic and more diverse than their larger counterparts. In the commercial sector, small firms are targeting niche markets within the recorded arts—for example, the market for classical recordings has been abandoned by larger firms because it does not provide the margins and volume that larger firms require. In the nonprofit and volunteer sector, small organizations have increasingly less in common with larger nonprofits in terms of programming, audience demographics, and the professional status of most of their artists. They are focusing on low-budget live productions that rely heavily on volunteer labor. Many cater to local and specialized markets, particularly ethno-cultural communities and neighborhoods. Others continue to provide opportunities for hands-on participation for nonprofessional artists (McCarthy et al., 2001).

In short, as the factors driving both the demand and the supply of arts in America change, the organizational ecology of the arts environment is becoming more complex. In the process, the traditional distinctions that have been used to describe the arts world are no longer as salient. The distinction between the commercial and nonprofit sectors, for example, is becoming blurred. Rather than being viewed as separate and distinct, these sectors are increasingly viewed as complementary components of a complex arts and entertainment system in which ideas, functions, and resources—including artists—move across sectors (DiMaggio, 1991). Moreover, increasing attention is being given to the volunteer or unincorporated sector and the role it plays both in providing opportunities for hands-on participation and as a venue for local community involvement in the arts. Similarly, artistic disciplines are no longer as distinctive as they have been in the past because they incorporate multiple disciplines and adopt a variety of media in their performances and presentations.

This is particularly true of the media arts, where the distinctions among film, video, and digital art have made the individual medium less important (Manovich, 1999). Instead, distinctions by size and function have become more important. As we have already noted, the kinds of programming offered, target audiences, and funding patterns increasingly vary by size rather than sector. Organizational mission or purpose is also becoming more important. Most art organizations seek to perform multiple functions, but an arts organization's focus—presenting, training, community development, or experimentation and innovation—is likely to affect not only the types of programs and work that it provides but also the types of audiences it targets and the sources of funding on which it relies. For example, while large presenting organizations are increasingly targeting broad-based audiences to expand their earnings, smaller presenting organizations may focus on niche or specialized audiences—often identified in terms of geographic or special-interest communities. Organizations that focus on training or innovation, on the other hand, are less likely not

only to target traditional audiences but also to be able to sustain themselves by relying on earnings.[6]

These changes are also evident in the policy arena in two respects. First, the range of policy-related issues of concern to arts organizations and artists has expanded considerably. Questions relating to intellectual property issues, access to and control of such distribution channels as the Internet, and appropriate business models[7] are not only broader than in the past but are also shared across sectors. In addition, the policy debate has shifted from an exclusive focus on public funding to a broader concern with the public purposes or role of the arts and how the different components of the arts system serve those purposes (American Assembly, 1997). Consequently, arts organizations need to adopt a more sophisticated and broader view—not only with regard to traditional questions of programming, audiences, and funding but also with regard to their interaction with society and how they raise revenues to support their activities.

THE ROLE OF TECHNOLOGY

Technology has played a major role in this ongoing transformation. New technologies for distributing the arts have allowed individuals to personalize their arts consumption and the ways in which they participate in the arts and have thus promoted the development of niche markets. Technology has also provided artists with new means of creating art as well as new opportunities to communicate directly with their audiences and to collaborate with their colleagues in this country and abroad. Concomitantly, technology is changing the behavior of the organizations that produce, present, distribute, market, and collect art by expanding both the size and the geographic spread of the arts and entertainment market, the costs and benefits of success and failure, and the business models upon which their operations are based.

Understanding the relationship between art and technology is important because of the rapid pace of technological change and the increasing role of technology in the arts. Indeed, despite the fact that few historians would deny the pervasive role that technology has played in shaping political, social, and economic developments throughout the modern era (Marvin, 1988; Landes, 1998), art historians have, until recently, tended to ignore the influence technology has had on the arts (Lovejoy, 1992).

[6]The principal market for organizations focused on training and experimentation, for example, may not be traditional consumers but rather foundations, corporations, other artists, and universities.

[7]The Creative Capital model, in which funded artists agree to return a portion of the profits generated by their projects to a fund that is subsequently used to fund future media and visual arts projects, provides an example of such a business model.

Evidence of these effects abounds. For example, technology has spawned entirely new art forms, as the history of the media arts attests. This process is not unidirectional. Indeed, the media arts provide ample historical examples of the complex relationship between technological change and the creation of art. Furlong (1983) describes how new artistic visions and practices have driven technological innovation just as new technologies have created new ways of producing art. From the emergence of photography following the invention of the camera in the 1830s, through the development of film after the invention of the motion picture camera, to video art in the wake of television, and most recently, the emergence of digital and web-based art on computers, technology has given rise to a host of new art forms.[8]

Similarly, technology has played a major role in shaping how the arts are distributed. The introduction of motion pictures, for example, was instrumental in the decline of live proprietary theaters during the first few decades of the 20th century (Baumol and Bowen, 1966). In turn, recorded music, radio, and television each played an influential role in transforming how the arts are produced and distributed (Kreidler, 1996). Use of the Internet as a medium for transmitting recorded music, film, and video to consumers—in addition to the written word—has already begun to alter the organization and role of intermediaries in both the performing and literary arts (Stroud, 2000). And the Internet shows promise of creating more direct links between artists and their audiences and further reshaping how art is distributed and experienced.

But the emergence of new art forms and distribution channels may be only the most obvious of technology's effects on the arts. As Benjamin (1986) pointed out in his seminal article, "The Work of Art in the Age of Mechanical Reproduction," technology "transforms the entire nature of art." These effects are manifested in the size and character of the audience for the arts, in how individuals experience them, in the motivations and practices of artists, and even in the social purposes of art (Lovejoy, 1992).

By facilitating the reproducibility of the arts, for example, technology has made the arts accessible to mass audiences in ways that were difficult or even impossible before such technological advances as film and video. Films and the broadcast media, for example, have expanded public access to the arts far beyond the reach of such traditional venues as museums and theaters and freed the arts from the geographic constraints imposed by the need for market thresholds sufficient to support production and distribution. Moreover, improvements in reproduction and transmission technologies have reduced the

[8]Indeed, as we noted above and discuss in more detail later, technology has tended to diminish the importance of the individual medium and artistic discipline as organizing principles in the arts.

aesthetic disadvantages of non-live performances and appear to have contributed to a growing preference for participating in the performing arts through the media rather than by attendance at live performances (NEA, 1998a; McCarthy et al., 2001). Finally, technologically influenced changes in the contemporary art aesthetic have shifted the focus away from viewing art as an object to experiencing it interactively. As a result, the audience member has been transformed from passive observer to active participant in the artistic process, exemplifying Duchamp's dictum that "the viewer completes the work of art" (Rush, 2001). This transformation of the artistic experience is perhaps most pronounced in certain forms of digital art. Here, the art exists not as an object to be viewed but is, in fact, produced by the interaction of the audience with the program created by the artist. Indeed, Lunenfeld (2000a) describes this phenomenon, which he terms the aesthetic of the "unfinished," as characteristic of much digital art.

Correspondingly, the audience for such work may be more accurately described as "users" rather than viewers. Just as technology has transformed the audience for art and the ways in which individuals participate in the artistic experience, it has also transformed the ways artists see their role. As Lovejoy notes, from the late Renaissance "the focus of art centered on the search for visual accuracy and harmony and the solution of issues related to composition and pictorial structure as much as it did on allegory or metaphor" (Lovejoy, 1992, p. 27). Moreover, she goes on, "photography, video, and the computer have dramatically changed the possibilities for visual representation allowing for the dynamic analysis of motion, time, space, and the abstract relations between them" (Lovejoy, 1992, p. 4). Indeed, contemporary artists have not only explored the relationship among these concepts and how they shape our experience but also their personal reaction to them. These new ways of perceiving reality and the reactions of artists to them have been central themes for most of the major art movements of the 20th century.

The past century has seen many examples of this phenomenon. Within the aesthetic domain, for example, many of the major art movements of the early 20th century, such as Dadaism and Cubism, consciously rejected the traditional view of what constitutes art and, in particular, the notion of an art work as a commodity of value. Similarly, the Fluxus-inspired art happenings and installation art works of the 1960s and 1970s were often consciously presented in an ephemeral form to counter the traditional views of art as a collectible object and the notion of audience as viewer. Often these challenges to traditional notions of art assumed a social as well as an aesthetic dimension, as reflected in the work of Nam June Paik, Douglas Davis, Richard Serra, and others who used

television to critique the mass media and their influence.[9] Indeed, much of modern art can be viewed as a critique of mass society and its mechanistic view of humanity. Not surprisingly, such artistic challenges have also been directed at political targets on both the right and the left. This questioning of the political order is also obvious in the themes chosen by filmmakers and others, which focus on those who have traditionally been regarded as outside the mainstream (e.g., ethnic minorities, gays, immigrants, the poor).

The exact shape of the arts world in the future is, of course, unclear. But it seems certain that technological developments will continue to play a central role in shaping that future. Technology will have implications both for the various components of the arts environment (audiences, artists, art organizations, and funders) and, as Benjamin (1986) suggests, for the nature of art itself. Since the media arts have been the most aggressive in their use of technology, they provide a window into that future.

[9]Schneider and Korot (1976); Rush (2001).

THE DEVELOPMENT OF THE MEDIA ARTS

One of the central challenges facing the media arts is to establish a common vocabulary for parsing them. Unlike the performing, visual, and literary arts, where established disciplinary categories are typically used to compare art forms,[1] there is no common standard for distinguishing among the media arts. Sometimes the media arts are described in terms of the technology used to create them, at other times in terms of the functions of the work, and at still others in terms of the specific styles of the work.

Each of these approaches can be found in the literature. Technological approaches, for example, sort the media arts by the media used and emphasize the connections between changes in technology and the artistic practices using those technologies (Renan, 1967; Lunenfeld, 2000b; Antin, 1986; von Uchtrup, 1999). Functional approaches, on the other hand, focus on the purposes of the work and how artistic practices within a functional tradition have changed regardless of the medium that is used (Rosenthal, 1988; Bruzzi, 2000; Rees, 1999). Finally, approaches that sort the media arts by subdisciplines tend to focus more on the aesthetics of the art and the ways in which those styles are represented in the works of specific artists (Rush, 2001; Hanhardt, 2000).[2]

This situation appears to be a by-product of the youth of the media arts and their early stage of development. Media artists, for example, appear to have devoted more attention to developing their artistic practices than they have to identifying the distinguishing features of the media arts. This is evident in the

[1]In the performing arts distinctions are typically drawn along disciplinary grounds, e.g., opera, dance, music, and theater. In the visual arts, distinctions are usually drawn by medium—painting, sculpture, the decorative arts, photography, installation art, or graphic art. In the literary arts, distinctions are typically drawn by genre—fiction, nonfiction, and poetry. Further distinctions within each of these art forms can be drawn—e.g., dance can be subdivided into ballet, modern, and ethnic just as fiction can be divided into novels, novellas, and short stories.

[2]Subdisciplines refer to the range of art forms within the media arts, such as narrative films, installation art using media, Internet art, and documentary video. A subdiscipline can be thought of as the combination of the medium used to create the art and the purposes for which the art was created. In practice, subdisciplines represent the very different styles of media art.

literature on the media arts, which is much more likely to trace the development of artistic practices than it is to discuss the organizational and structural features of the media arts as a distinctive genre. To highlight the diversity of approaches that has characterized the development of the media arts, this section briefly reviews their history and assesses the current state of the media arts literature.[3]

HISTORICAL DEVELOPMENT OF THE MEDIA ARTS

Artistic practices within the media arts have continuously evolved as technology has changed. Indeed, one of the distinguishing characteristics of the media arts is the penchant of media artists first to adopt new technologies and later to adapt them for a variety of artistic purposes. For example, even before the invention of the motion picture camera in the last decade of the 19th century, artists like Edward Muybridge in his locomotion studies, were experimenting with photography and demonstrating its implications for perceptions of time, space, and motion. These early photographic studies were a precursor of the avant-garde or experimental tradition that has been present ever since in all forms of the media arts (Lovejoy, 1992).

Indeed, three traditional artistic functions—storytelling (narrative), providing insight into the world as it exists (documentary), and conceptual work that provides a perspective on how we perceive the realities of time, space, and motion or explores the properties of media for artistic purposes (experimental)— are evident in film, video, and computer or digital work. Although the specific styles used within these traditions often change, the underlying functions provide a common metric for organizing a discussion of the media arts, how they differ, and how they have changed.[4]

Early 20th Century: Film

From its genesis at the end of the 19th century, film followed two separate disciplinary lines: narrative, mostly commercial works like D. W. Griffith's "Birth of a Nation," Mack Sennett's comedies, and the short films of Georges Melies in France; and experimental works by European visual artists like Fernand Leger, Salvador Dali, and Man Ray and early filmmakers like Fritz Lang, Luis Buñuel, Dziga Vertov, and Sergei Eisenstein. During these early years, innovations in

[3]As one of our reviewers noted, we recognize that this historical discussion is selective. While it highlights different approaches within the media arts, it is not designed to provide a comprehensive treatment of these approaches or their historical development.

[4]As noted above, these different functions are not mutually exclusive and are often combined in individual works.

technology (e.g., the invention of sound films) and artistic techniques (e.g., slow motion, montage, close-ups, and editing) were adopted in both narrative and experimental films.[5] By the 1930s, however, narrative films, at least in the United States, were largely the province of the commercial or studio sector—a category of work that, as we have noted, has not traditionally been included within most definitions of the media arts. Renan (1967) points out that most of the independent film work in the United States during the next 30 years fell predominantly in the experimental or underground tradition. This work often expressed the personal visions of the filmmakers. Not only did it explore more controversial and experimental topics, it also introduced a more conceptual style that Renan (1967) has referred to as "personal art filmmaking"[6] and Youngblood (1970) cited as the precursor to the end of drama.[7] Finally, although the documentary tradition flourished later, especially with the introduction of video, documentary works, such as Robert Flaherty's "Nanook of the North" and "Man of Aran," had already emerged as a third major tradition within the film genre by the 1930s.

Early 1960s: Video

Video, the second component of the media arts, became available several decades after television was first demonstrated (1920s) and broadcast (1939) (Vogel, 1998). The high costs of early video equipment limited its adoption by artists with some exceptions, such as Nam June Paik and other members of the Fluxus Movement (Rush, 2001; Hanhardt, 2000). It was not until the Sony Portapak was introduced in 1965 that artists starting turning to video in substantial numbers. By that time, commercial television was firmly established and much early video work was explicitly created as an alternative to it.

This work took a number of different forms (Furlong, 1983; D'Agostino, 1985). One was explicitly designed to promote social action and provided a foundation for the growth of the documentary tradition within the media arts.[8] A second, more experimental component pursued a "new kind of 'media ecology' by creating video environments . . . designed to expose and circumvent the one way delivery of commercial television . . . or to use technology to meld 'man' and the

[5]Description of these developments can be found in Renan (1967) and Manovich (2001b).

[6]Renan, 1967, p. 102.

[7]Examples of the former can be found in the works of Stan Brakhage and George Markopoulos (Rush, 2001). Andy Warhol's films provide examples of the latter (Renan, 1967).

[8]Examples include the work of video artists Frank Gillette and video collectives such as Videofreex and Top Value Television (TVTV), which produced "Four More Years," alternative coverage of the 1972 Democratic and Republican conventions (Rush, 2001).

environment."[9] The third, focusing on creating images that were different from standard television, was more conceptual and "had to do with . . . exploring the essential properties of the new medium."[10] This alternative TV movement and the multiple directions it followed led the way for a much wider group of artists. Some of them pursued the documentary line, while others incorporated video and film and other media into installations in museums and various public spaces. The latter group gave rise to a new set of artistic practices: Some video artists pursued conceptual work exploring the video medium, and others continued the strand known as installation art using media.[11]

1960s and 1970s: The Launch of the Media Arts Movement

The media arts movement was founded by pioneers in the film medium: avant-garde filmmakers who viewed films as primarily artistic rather than commercial products and documentary filmmakers who felt that standard news sources were not giving an accurate picture of minority and third-world experiences. They believed that the production and distribution of films were dominated by establishment institutions both in the news media and the Hollywood studio system. To produce their art, they needed access to expensive production equipment for image-making. To distribute their work, they needed access to exhibition venues and distribution mechanisms outside the commercial system. To meet these needs, they founded Film Forum in the early 1970s, the Association of Independent Video and Filmmakers (AIVF) in 1973–1974, and the Independent Feature Project (IFP) in the late 1970s.[12] The movement has subsequently spawned a reinvigorated tradition of independent narrative and documentary work.

As the quality of video and film equipment rose and its costs dropped, the number of artists adopting these forms and the variety of their arts expanded. The effects of these changes, however, were felt unevenly. Independent narrative films, which had dropped off with the growth of the studio system, began a resurgence—growing from around 25 titles a year in the 1960s to over 1,000 titles today.[13] Much of this work focused on topics considered too daring or personal for the established studio system.

[9]The quotations in this paragraph are taken from Furlong (1983), p. 35.

[10]For example, the work of Woody and Steina Vasulka (founders of "The Kitchen"—a center of this work in the 1970s), Richard Serra, and Vito Acconci.

[11]For example, Jud Yalkut with his experiments integrating video with the more traditional medium of film.

[12]See AIVF's history of the early media arts movement: http://www.aivf.org/about/history.html.

[13]The figures cited here are based on information provided by Geoffrey Gilmore of the Sundance Institute.

Documentary film and video production also grew as new techniques like cinema verité emerged, video equipment became cheaper and more accessible, the prospects for public and private funding seemed to improve, and media artists, like others in American society, began in the 1960s to challenge established institutions. As Boyle (1990) points out, this new documentary movement pursued three different approaches. One, guerrilla television, most notably but by no means exclusively TVTV, began to challenge the objectivity of traditional TV journalism and the established view of public issues. A second, community video, focused less on providing an alternative approach to traditional journalistic practices than on using video and documentary as a vehicle for community organizing.[14] Often this entailed giving local community residents access to video equipment to comment on local community issues. A third approach included a new generation of minority and radical filmmakers who sought to inject their perspectives into a system that had heretofore not represented them. As Boyle notes, by the 1980s a more conservative political climate, along with the failure of public and private funding prospects to measure up to artists' expectations, led to the collapse of the first two of these approaches.[15]

1980s and 1990s: Digital Technology and the New Media Arts

The computer, the third tool of media artists, has in many ways revolutionized the media arts—to the extent that many observers of this art form refer to the variety of art practices based on computers and the Internet as the "new media" arts. Although the computer is based on Charles Babbage's "analytical engine"—conceived in the 18th century and operationalized in the 1940s—it was not until the 1980s that the computer began to be adopted on a significant scale for artistic purposes (Manovich, 2001a, 2001b). This development coincided with the switch from batch to interactive processing and the introduction of the Internet. Since the 1980s, not only has the computer been used for the traditional narrative, documentary, and experimental functions that are now an integral part of the media arts tradition, it has also spawned such new disciplines as interactive art and web art. In addition, new media art can include basic research and science-based work. In the words of one new media artist

[14]In this sense, community video has more in common with arts organizations whose mission focuses on community development rather than promoting the canons of specific disciplines (McCarthy and Jinnett, 2001). Prime examples of the community video approach were Broadside TV in Tennessee, University Community Video in Minneapolis, and New Orleans Video Access Center (NOVAC) (Boyle, 1990).

[15]Bullert (1997) also discusses the public funding issue and how it affected documentary film and video.

and author, "One person's new media art is another person's social interven-
tion and a third person's scientific research" (Jennings, 2000).

RECENT TRENDS

As the media arts continue to evolve, the traditional distinctions among narra-
tive, documentary, and experimental work remain important, even if individual
works combine these functions in novel ways. As noted above, the production
of independent films has exploded with an increasing number of such films
crossing over to the popular commercial sector. Indeed, as we discuss in more
detail in the next chapter, this expansion has raised new questions about how
to define independence. Documentary works, which tend to focus on less polit-
ical and more personal issues, are also thriving. Moreover, the growth and
acceptance of experimental and conceptual work has increased, especially with
the emergence of installation art.

In contrast, the importance of media as a classifying device seems to have
declined. Indeed, the ability of digital technologies to facilitate multimedia ap-
proaches by incorporating film, video, audio, text, and graphics has blurred
traditional media-based distinctions. Both film and video artists, for example,
frequently incorporate digital elements in their work. Thus, the traditional
media-based distinctions among the media arts are less salient now than they
were prior to the advent of the new media. Manovich cites the ability of the
computer and the Internet to create "multimedia documents . . . something
that combines and mixes the different media of text, photography, video,
graphics, sound" as creating a "new communication standard."[16] In turn, he
refers to the need for a new "post-media aesthetic" (Manovich, 2001a, p. 3).

In addition to creating new art forms, such as web art, and altering how artists
use the tools of their art, the computer is also allowing artists to experiment
with the traditional narrative, documentary, and experimental formats. Not
only have narrative media artists, for example, adopted the computer-generated
special effects used by major commercial studios, they are also employing
computer-aided techniques that enable their audience/users to shape the
sequence and the context of the stories. This work functions in much the same
fashion as hypertext links that allow readers to alter the traditional front-to-
back sequence of the written text. Similarly, documentary artists can add a wide
variety of contextual material (maps, documents, background interviews, etc.)
to the work they create. These features enable the artist to convey to the viewer
material that not only enriches the viewer's understanding of the artist's per-

[16]These various disciplines do not include the host of related "art" forms such as computer games,
architectural design, and a variety of other applications (Lunenfeld, 2000b).

spective but also gives the viewer more control over the experience. Other media artists are combining documentary and narrative in their projects. An example is "Refresh," in which Elizabeth Diller and Ricardo Scofidio collect images from live office webcams around the world, then fabricate a narrative in text and additional staged filming to explore the effects of live video on everyday life.

Finally, the possibilities for interactivity between artists and users/viewers are even more pronounced in certain experimental media arts works. Here, the interaction between the user and the artwork guides the artistic creation. For example, one piece in the Whitney Museum's Data Dynamics show involved an Internet user typing words into a computer. The artists' program then translated those inputs into a blueprint for individual apartments, which appeared on the user's computer screen and a 3-D image projected in the Whitney gallery. The apartment walls in this 3-D image were pictures linked to the user's words by a search of the Internet.[17] In another work, the user inputs search terms into the computer and the artist's program creates a visual display of the search process.[18] A similar piece was a live work that could be partly controlled by anyone who visited its web site.[19] This piece gave people outside the museum a chance not only to view parts of the exhibit, but also to participate in creating the art on display. In all of these examples, without a user to interact with the artist's program there is no art. In essence, these new forms of media art give substance to Duchamp's dictum that "the viewer completes the work of art."[20]

Given the tremendous diversity in the types of products, styles, artists, and thus audiences and organizations working within each of these media forms, sorting the media arts by the medium used in creating the art is less useful to understanding the organizational structure of the media arts than the purpose or function of the artwork. In fact, Manovich has declared that "in the last third of the twentieth century, various cultural and technological development have rendered meaningless one of the key concepts of modern art—that of the medium" (Manovich, 1999, p. 1). Moreover, the tremendous diversity of styles

[17]"The Apartment, 2001," by Martin Wattenberg and Marek Walczak, part of the "Data Dynamics" show at the Whitney Museum of American Art in 2001 (Kimmelman, 2001).

[18]Part of the "Art in Motion" show at the Santa Monica Museum of Art, February 2000.

[19]"milkmilklemonade.net," by Lew Baldwin, part of the "BitStreams" show at the Whitney Museum of American Art in 2001.

[20]A corollary is the burgeoning area of portable art in which a media artist creates a piece a viewer may download to a PDA or personal computer to experience. For example, David Claerbout offers viewers the choice of three flowers to load into their computers for a week. The flower progresses from bloom to decay, and eventually disappears (from Dia Center web site: http://www.diacenter.org/rooftop/webproj/index.html).

and subdisciplines that have arisen in the past decade makes discipline an unwieldy concept for organizing a discussion of the media arts.

Despite this change, most treatments of the media arts, including work employing digital technologies, tend to emphasize the different media within this artistic genre. This approach stands in sharp contrast to the way the media arts are viewed internationally.[21] Media artists, including U.S.–based artists, are reported to have greater visibility, more opportunities for exhibitions, and more commissions overseas than in the United States (Manovich, 2002). Indeed, symptomatic of the more fragmented approach toward the media arts in the United States is the fact that different branches of the media arts are more likely to be handled by different curators in museums and reviewed by different art critics here than abroad. For example, the web site of ZKM, a major German media arts center, includes institutes and departments on contemporary art, visual media, media and economics, music and acoustics, web development, and basic research.[22] Only recently have a few American institutions, such as the Walker Art Center, the Whitney Museum, the San Francisco Museum of Art, and the Guggenheim Museum, begun to take a more comprehensive approach to the media arts.[23] Similarly, training centers for the media arts in the United States often have separate departments for the different branches of the media arts.[24] Finally, many of the major festivals for the media arts began in Europe— for instance, Ars Electronica in Austria and ISEA in the Netherlands.[25]

While the reasons for this difference in approaches are not altogether clear,[26] the consequences are quite striking: more visibility for the media arts and media artists, more diversified and greater funding opportunities (both from government and private sources), a clearer recognition of the importance of the

[21]We are indebted to Lev Manovich for pointing this out to us. Our discussion of the international perspective on the media arts benefited greatly from Manovich's suggestions.

[22]See http://on1.zkm.de.

[23]See, for example, the traveling exhibit curated by Steve Dietz of the Walker Arts Center titled "The Telematic Connections: The Virtual Embrace" (http://telematic.walkerart.org) and BitStreams at the Whitney Museum of American Art.

[24]As Manovich has noted, this practice is less common on the West Coast. Indeed, each of the University of California's campuses has a degree program in the new media arts.

[25]An interesting example of this more integrated approach and how it has changed over time is provided by Druckrey et al. (1999).

[26]Several potential explanations have been suggested, including the tendency for European governments and business interests to recognize the importance of research on the media arts as of vital economic importance to these countries' ability to compete with the United States in the new information age; the fact that many of these new technologies, although first introduced in the United States, have become so rapidly assimilated into American society that they become almost invisible overnight; and the fact that the new media arts in the United States are "contaminated" by their close relationship to the mass media of cinema, television, the recording industry, and computer games (Manovich, 2002).

media arts as a genre both economically and culturally, and a fuller, more inte-grated understanding of how their various components are related. Given the changing organizational ecology of the arts in America, the media arts in the United States would do well to move in Europe's direction.

INFORMATION ON THE MEDIA ARTS

As this review indicates, a spirit of experimentation and innovation has pro-duced tremendous dynamism within the media arts that is reflected in the diversity of art forms and artistic practices it has spawned. This focus on artistic practice is clearly apparent in the growing body of literature on the media arts. This literature can generally be sorted into work that was written before the emergence of digital and computer-aided art (around 1990) and work written since. Before the advent of digital art, the media arts were dominated by film, video, and installation art using film or video. Work written since then has focused on computer-aided art.

In both cases, the literature can be divided into two categories. The first cate-gory includes discussion of the aesthetics and critical reviews that focuses on profiles of individual artists and exhibitions, histories of the development of the different media and the artistic styles and techniques used by media artists, and their implications for the media arts and the art world more generally (Manovich, 2001a, 2001b; Lunenfeld, 2000a, 2000b). The second category includes a wide variety of volumes that provide practical guidance and manuals for individual media artists.

In short supply in this literature are studies that examine such organizational features of the media arts as the size and characteristics of their audiences, the employment and background characteristics of media artists, and the number and types of organizations that fund, produce, and distribute the media arts. As a consequence, we have little empirical information with which to describe these structural features of the media arts. This situation may well be changing. In its most recent strategic plan, NAMAC, the principal organization for indi-vidual media artists who work outside the media industry and commercial marketplace, has identified research and planning, including mapping the media arts field through data collection, as a central component of its strategy.

Although the current information situation may be understandable given the relative youth of the media arts, it poses a real challenge when building a com-prehensive assessment of their structural features and how they compare with those of the more established performing, visual, and literary arts. Clearly, more attention needs to be devoted to developing common standards for collecting systematic data about the media arts. This effort will also require a common vocabulary for describing and classifying them. Indeed, there appears to be

considerable disagreement among media artists on the terminology they use to describe their work (Rockefeller Foundation, 2001). The current situation makes it almost impossible to develop common standards for collecting and organizing data about the media arts, for communicating a clear message about them to the external world, and even for media artists to identify themselves as media artists rather than simply as artists who work with film, video, or computers.

COMPARING THE MEDIA ARTS

The previous two chapters have described the changing structure of the arts world in America and the diversity of approaches that have characterized the media arts throughout their development. This chapter compares the media arts with the other arts and examines differences among the media arts in greater detail. These comparisons are structured according to the analytical framework from our performing arts analysis: audiences, artists, organizations, and funding. In drawing comparisons among the media arts, we primarily distinguish among different types of work in terms of their function (narrative, documentary, and experimental) rather than the media used or the specific style of the artwork.

As we noted in our description of information available on the media arts, the absence of empirical data on their organizational characteristics presents a major challenge for a systematic comparison of audiences, artists, organizations, and funding and how they vary among the media arts. Consequently, in the comparisons below, we draw heavily on qualitative findings from the media arts literature and the interviews we conducted with individuals in the field.

AUDIENCES

Gaining access to wider audiences has been an ongoing objective for the media arts.[1] But as we noted earlier, patterns of participation in the arts have been changing. In particular, we highlighted three related changes: First, the arts face increasing competition for individuals' leisure time. Second, the forms of individuals' participation in the arts are changing as more people participate through the media or in a direct "hands-on" fashion while rates of attendance at live performances remain stable. Finally, these changes are affecting not only how people become involved in the arts but also which art they choose. In this chapter, we examine whether these trends will affect the media arts in the same

[1]See our earlier discussion of AIVF and the emergence of the media arts movement.

ways as they do the other arts and whether these effects are likely to vary among the media arts.

Technology Is Changing Arts Participation

As we indicated in our earlier discussion of the changing arts environment, these trends are related to shifts in Americans' leisure patterns and to technological developments that, in principle, should be conducive to expanding audiences for the media arts. As leisure time has become more fragmented, for example, Americans are choosing forms of arts participation that they can tailor to their own schedules and interests. These choices favor activities that individuals can enjoy at home and according to their schedules and interests—traits that are more characteristic of the media arts than of the performing or visual arts. In addition, increasing public use of computers for leisure time activities— from games to web surfing—should increase participation in computer-related forms of the media arts. Computers can provide opportunities for "amateurs" to become directly involved in creating art and can expose a growing pool of potential consumers to the arts, possibly including many who do not already participate.[2]

At the same time, improvements in reproduction and transmission technologies have made it easier for individuals to enjoy the kinds of art they want, when they want, and where they want. These trends are advantageous for the media arts, which are on the cutting edge of such technologies. The reproducibility and portability of film and video work, for example, make them well suited to home viewing through videocassettes (Walker and Klady, 1986) and, more recently, DVDs.

Similarly, the production and distribution of art using computer technology— which the media arts have been quick to adopt—provide consumers with considerable flexibility in choosing the type of art they want to experience and how they have access to it. The Internet, for example, allows consumers to gain access to recent work regardless of where they live and to do so more rapidly than if they had to rely on traditional distribution sources. Moreover, as Miller has pointed out, it has opened up new markets for media arts products, e.g., short films, which had been all but abandoned by mainstream theaters and

[2]As John Ippolito has suggested, more people may surf prominent Internet art sites than attend museums. Indeed, he says that by separating art from the established art circles and venues, art available on the Internet is likely to reach a very different (and larger) population (Ippolito, http://www.guggenheim.org/internetart/welcome.html).

broadcasters (Miller, 2000).[3] Finally, by allowing direct interchanges between artists and consumers as well as among consumers who might share an interest in particular forms of media art, it provides a channel for exchanging information about new work.[4]

Whether this new flexibility actually translates into increased access and expanding audiences, however, may well vary for different types of media art because individual consumption is predicated on awareness and interest in various types of art. Our work on the performing arts suggests, for example, that there are significant differences in marketing strategies and budgets between work that is thought to appeal to broad cross-sections of the population and work that is believed to appeal to more specialized or niche audiences. Work thought to have general audience appeal can attract commercial distributors who might invest the resources necessary to market and distribute it widely. Such work typically gains access to wider audiences and, in return, generates higher revenues. Work thought to appeal to more specialized audiences, on the other hand, tends, if it is distributed or exhibited at all, to be relegated to smaller distributors or exhibitors who, with fewer resources to invest in marketing, tend to focus on niche markets.

The behavior of distributors is likely to be especially important in the media arts for three reasons. First, given the tradition of experimentation and innovation, much media arts work may be viewed as more likely to appeal to specialized audiences.[5] Second, many, if not most media artists, are unaffiliated with established media or commercial organizations and thus must rely on critics and other intermediaries to be recognized and marketed. Third, as media arts work and the number of media artists has proliferated, the probability of any individual work or artist getting recognized will increasingly depend upon how the work is marketed and distributed.

Clearly then, decisions about the potential audience for media arts work play a central role in determining how it is marketed and, thus, who has access to it. Often these decisions appear to be based less on the artistic quality of the work than on a host of other factors, such as content, format, and audience accessibility (Gilmore, 2001). Work that is deemed controversial, whose format or pro-

[3]As Miller puts it, "entrepreneurs have turned to shorts because they can be acquired cheaply, delivered swiftly to consumers with PCs hooked up to high-speed lines, and watched in a few idle moments from almost any den, dorm room, or cubicle" (Miller, 2000, p. 4).

[4]This type of information exchange appears to have played a major role in the commercial success of the 1999 independent film "The Blair Witch Project."

[5]However, presenting media art may also pose special technological challenges, such as working with obsolete technology (e.g., programming languages, operating systems, hardware) or ephemeral art work (some video art and web art) or particularly complex technologies (types of projectors, computer hardware, plasma screens, etc.).

duction quality is not suited to standard theatrical release or broadcast, or that is judged to be less accessible for broad-based audiences is relegated to limited distribution—when it is distributed at all.

Audiences Differ for Different Types of Media Art

Narrative Work. For a variety of reasons, many of the media arts are relegated more to niche than to broad-based audiences. The principal exception to this seems to be narrative works. Since two-thirds of Americans attend films annually and over 90 percent watch television, the potential market for narrative works of media art appears to be quite large. Indeed, the growing commercial success of selected independent narrative films during the past two decades testifies to the potential market at least for selected narrative films (*American Cinematographer*, 1996).[6]

However, a major issue in defining the market for independent narrative work is the ambivalence with which some media artists view commercial distribution and success. This issue is underscored by the sharp distinction often drawn by media artists between commercial, i.e., studio, and independent narrative films. The tremendous commercial success of some independent narrative films during the past decade has, for example, spawned increasing criticism that these works are not really "independent." Geoffrey Gilmore, co-director of the Sundance Film Festival, argues in response that this criticism confuses commercial success (and thus broad audience appeal) with formulaic market-driven work (Gilmore, 2001). While acknowledging that independent films are difficult to define, Gilmore suggests that the key to the distinction between studio and independent work should rest with the subject matter, creativity, and independence of the work—not with its production budget or commercial success.

Another approach to the definition of independent work has been suggested by Lars von Trier's Dogme95 Manifesto, which lays out a series of rules that should govern the production of an independent film. Whether the rules embodied in the Dogme95 Manifesto represent a blueprint of independence or an aesthetic protest against slick Hollywood productions is unclear (Roxborough, 2002).

Still another approach argues that independence describes the filmmaker's control over the creative process. If the filmmaker does not control the writing, filming, editing, etc., the film is not independent. Differences of opinion about what constitutes an independent film are apparent in the many criteria for

[6]Interactive narrative work may represent an exception to this statement because it seems better suited for distribution to individual users.

selection by various independent film festivals around the world. But the relationship between independent work and how that work is distributed directly affects who has access to it.

In any case, as Gilmore has noted, of the 1,000 independent films (by his definition) that have been produced in each of the past three years, only 75 to 100 have had any kind of theatrical release. Indeed, it appears that independent narrative works can be divided into those that cross over into the commercial sphere (and are thus given relatively wide marketing and distribution) and those that are relegated to the network of informal and independent distribution channels that has come to be called the "microcinema" movement. This phenomenon refers to alternative venues and cinemas (often at mobile or temporary locations) that present short and feature-length films that fall under the "cultural radar" of mainstream movie theaters and/or art house cinemas.[7] In any case, despite the size of the potential market and the success of individual narrative works and artists, most narrative work receives very limited distribution and thus remains unseen or seen only in niche markets.

Documentary Work. In contrast to the potential popular appeal of narrative work, documentary work has historically had a more difficult time appealing to broad-based audiences. Boyle's brief history of the documentary suggests that, despite the success of individual documentary works and artists and the increased funding associated with local programming requirements for public television, the history of the documentary form in America is one of struggle for "air time" (Boyle, 1990). Boyle attributes this situation to a variety of factors. Many documentary artists, for example, focus on explicitly political themes designed to challenge the established political and social order. While consistent with the media arts' iconoclastic tradition, this practice limits their appeal to some distributors. Others have criticized documentary work as being of uneven production quality and in formats and lengths not suited for broadcast or theatrical showings. In addition, the often intensely personal and community-specific topics of documentary work may limit their appeal to broad-based audiences (Aufderheide, 1997; Feaster, 1998). Finally, for whatever reasons, commercial and public broadcasting as well as film distributors appear increasingly reluctant to air documentary work in general.

This reluctance to air documentary work may be changing since Boyle published in 1990, now that cable channels, such as A&E, the History Channel,

[7]In some respects the microcinema movement calls to mind the Film-makers Cooperative that was founded by Jonas Mekas in 1962. As Renan describes it, "the Film-makers Cooperative adopted a policy of distributing all films submitted to it . . . this was in line with the attitude that it was the film artist who knew what ought to be seen, not the distributors, not the exhibitors, and not the audience. Following this idea, a series of film showcases, operated by the filmmakers, were set up to insure minimal exhibition (Renan, 1967, p. 101). See also Bachar and Lagos (2001).

Oxygen, etc., are looking for and funding documentaries. But the future remains uncertain. Earlier expectations of wider market distribution in response to increased public funding in the 1970s failed to materialize despite the fact that, as Boyle points out, many of the techniques developed by alternative TV documentarians were subsequently adopted by established media. Without broader distribution, including support for marketing through the Internet and other new distribution channels, the market for documentary work will likely remain principally a specialized one.

Experimental Work. Given its conceptual focus and its innovative nature, it is not surprising that experimental work appears to have its greatest appeal in more specialized or niche audiences. After all, judgments about the size of potential audiences appear to be the key determinant in decisions about distribution, and the leisure literature suggests that innovative art, like the more technical aspects of most leisure activities, is likely to appeal only to audiences already knowledgeable about the arts. In the case of experimental work, this is likely to mean other artists, art aficionados, and art critics (Kelly and Freysinger, 2000).

Media artists creating installation pieces, for example, found it difficult to get critics and collectors to accept the new art form, even after museums and galleries began exhibiting it. Experimental or avant-garde films and videos have also traditionally had a difficult time finding venues (Renan, 1967). Similarly, interactive arts, such as Internet art or installation pieces that require interaction with audiences, may make such work inaccessible to broad-based audiences. Moreover, the fact that many experimental pieces were purposely designed to be ephemeral—in reaction to the view of art as a commodity—has no doubt contributed to this pattern (Lovejoy, 1992). On the other hand, as Ippolito has pointed out, some forms of experimental work are well suited to distribution over the Internet and can thus reach audiences they otherwise would not. Finally, some emerging forms of experimental art, e.g., art created by "cultural hackers," are designed to undermine traditional distribution channels and will likely have limited distribution (Rockefeller Foundation, 2001).

Given this situation, it may be unrealistic to expect experimental work to appeal to the market and be supported by it. Instead, a more apt model for the experimental media arts may be the sciences, where scientists, typically working at universities, perform basic research with subsidies from the public and private sectors. The private sector may further support such research after the applicability of the basic concepts has been demonstrated and a market established. Indeed, as we discuss shortly, media artists are increasingly collaborating with researchers and scientists both in universities and in the corporate sector. However, to develop this model, the media arts must continue to be open to

such collaborations and to promote greater understanding of its relevance to these sectors, as the media arts are doing internationally.

In sum, despite the fact that at least certain types of media art would seem to have a potential appeal to a wider audience, a combination of factors, including the behavior and beliefs of distributors, lack of audience familiarity with the art form, and the ambivalence of some media artists themselves toward commercial involvement, appears to have limited audience access to much of the media arts. As we discuss presently, these factors have direct implications for media artists and the channels through which the media arts are distributed.

ARTISTS

The size and range of the audience for the media arts affect not only who has access but also the ability of media artists to make a living from their art. This issue is a central theme for performing and visual artists as well (Alper and Wassal, 2000; Kreidler, 1996; NEA, 1982). In our discussion of the arts environment in Chapter Two, we highlighted three aspects of the labor market for artists and how it has been changing. First, we noted that artists face a more challenging labor market than other professionals. Second, as a result, most artists struggle to make a living in their chosen profession and typically must supplement their income as an artists with other sources of income. Finally, the number of artists has been increasing despite this situation. How do these trends compare with the situation in the media arts?

We lack the empirical data on media artists needed to make comparisons of the earnings and labor market conditions of media and other artists, but both the literature and our interviews suggest that the number of media artists has been increasing and that several factors have contributed to this trend. First, although we have no reason to assume that the earnings situation of media artists is dramatically different from that of other artists, the emergence and growth of the new media arts, e.g., computer-based work, appears to have attracted large numbers of new artists to the field. Second, declines in the costs of the technology used in the media arts have made work as a media artist more affordable. Third, the growth of university film schools and media arts programs has provided entry to the field to greater numbers of potential media artists.[8] Finally, by reducing the traditional barriers to collaboration between the commercial and independent sectors, the new media arts have expanded the employment options of the new media artists.

[8]There are now over 600 film, video, and communications schools and programs in institutions of higher education around the United States, plus close to 100 in Canada. These are in addition to the centers of commercial-based instruction, such as the Los Angeles Film School, the New York Film Academy, and the School for Film and Television.

These developments have not only increased the number of media artists, they have also expanded their diversity. As our brief history of the media arts indicates, many of the original media artists were either visual artists experimenting with film or early filmmakers exploring the new medium. As technological developments lowered the cost of film and video equipment, the number and diversity of new artists using film and video in their art increased sharply and included individuals from music and other artistic fields. The emergence of the media arts movement in the 1960s and 1970s and the subsequent appearance of regional training centers across the country in turn produced another generation of narrative and documentary film and video artists, including substantial numbers of minorities and women who viewed these technologies as providing them with an opportunity to tell their stories to wider audiences.[9] The ability of these media arts centers to provide an array of services to artists—training, use of equipment, support in obtaining funding and distribution—made them invaluable to many young artists (NAMAC, 2000a).[10]

More recently, the growth of film schools and programs in universities has dramatically increased the number of college graduates in filmmaking and other media arts careers. However, cutbacks in support for media arts centers, increasing pressures to develop work that can attract wider audiences and earnings, and the difficulty of earning a living in a field lacking broad distribution have led many of the current generation of new media artists to turn their efforts away from film and video per se to the personal computer and the new media arts.

The emergence of the computer in the new media arts appears to have had a profound effect on media artists. It has expanded the number of artists by attracting existing media artists to the computer-based arts. These artists represent not only a more diverse array of sociodemographic groups but also a wide variety of artistic and professional backgrounds. Many of the early practitioners of computer-related art, for example, were not artists at all but rather scientists who collaborated with artists in exploring the artistic uses of the computer.[11]

[9]The "Third World Newsreel" provides a notable example of an organization that has played a key role in fostering the creation, appreciation, and dissemination of independent film and video by and about people of color (http://www.twn.org).

[10]Our discussion of the media arts movement and the role of regional training centers have benefited from discussions with Gail Silva, executive director of the Film Arts Foundation in San Francisco.

[11]Rush (2001) describes some of these initial experiments. Steve Dietz, media arts curator at the Walker Arts Center, has compiled a timeline on the new media arts that shows both the history and the wide array of participants in this area. The timeline can be accessed at http://telematic.walkerart.org/timeline.

The new media arts have also dramatically increased the number and range of collaborations between traditional media artists, computer programmers, scientists, and a host of others.[12] In the process, new media artists have become involved in a wide range of interactions between the arts and the university and scientific sectors, which have not been limited, as was true in the past, to the traditional fine arts and art history disciplines (Rockefeller Foundation, 2001). The emergence of the new media arts has also afforded opportunities to work in a wider range of production settings—ranging anywhere from hobbyists working on their home computers, to media arts professionals working with a variety of equipment, to independents collaborating with other artists and computer professionals using the latest in hardware and software (NAMAC, 2000a).

These changes have also produced a wider range of interactions between artists and industry than has traditionally been the case. As a result, the traditional distinction between the commercial for-profit sector and the noncommercial arts has begun to blur in the new media arts (Rockefeller Foundation, 2001). Many new media artists, for example, are fully employed as programmers or have helped developed commercially marketable software. They use the earnings from these commercial activities to support their art.[13] In addition, many media artists have begun to assume such untraditional roles as entrepreneurs and researchers (Rockefeller Foundation, 2001).[14] Even when these activities do not provide sufficient earnings to support such artists full-time, they provide the new media artists with a wider range of employment options (and thus higher earnings) than have traditionally been available.[15] However, since the commercial sector is typically less interested in the art per se than in the technology that drives the art, some have voiced concern about whether these activities will enable artists to preserve their artistic focus (Rockefeller Foundation, 2001).

In addition, new distribution technologies have opened up opportunities for media artists to bypass the various intermediaries that have traditionally controlled access to their work. Although direct distribution from artists to audi-

[12]As Furlong (1983) notes, these collaborations did not begin with the new media arts. Several of the technological innovations that were instrumental in the development of video were created by individuals, like Eric Siegel and Stephen Beck, who got involved in art through their interest in technology.

[13]For example, John Klima, a media artist who is also a Wall Street programmer, is quoted as saying, "It takes less time to do a $2,000 programming job than to apply for a $2,000 grant that you might not even get" (Bodow, 2001).

[14]An interesting example of this phenomenon is presented in Laurel (2001).

[15]Although few artists of any type are able to support themselves exclusively from their art, there are major earnings difference between such artists as authors whose outside earnings are in professional occupations, e.g., teaching, and those who work in low-paid service jobs, e.g., actors who work as waiters. Media artists who are able to apply their skills in related fields, e.g., as programmers, will earn substantially more than those who do not.

ences remains more a possibility than an established reality, it could facilitate broader distribution for their work and, in the process, provide them with new earnings possibilities.

In sum, a growing number and range of collaborations between media artists and the commercial sector, combined with improvements in technology that allow artists to bypass the traditional middlemen in reaching their audiences, offer media artists a wider array of employment and earnings options than has historically been the case. However, they also raise several important issues for media artists.

First, although new collaborations with the commercial sector may provide new options, they also raise old questions about who should own the legal rights to creative intellectual property. These questions have become more prominent for the arts in general (Litman, 1996; Lessig, 2001), but they may be even more troublesome for media artists because of the complex nature of new media arts work (Gunn, 1996). Two recent laws on copyright issues are particularly germane to the media arts. The 1998 Sony Bono Copyright Extension Act, which lengthened copyright protections, could limit public access to historical works and pose a special problem for efforts to digitize and restore classic works (Albanese, 2002). The Digital Millennium Copyright Act of 1998 places severe limits on the use of anything that circumvents digital copyright controls (Cave, 2002).[16] New technologies also raise new copyright issues, e.g., is the code that an artist uses to create computer art protected, like a piece of music, or is that tantamount to protecting the paint and brushes used in the visual arts?

Second, and somewhat ironically, as new work and the channels for distributing that work proliferate, artists may become increasingly dependent upon intermediaries who are needed to help overloaded audiences identify the voices they want to hear.

Third, the potential downside of more market-oriented funding is that it may change the tenor of the art itself as well as who can afford to be a media artist. If content is driven primarily by economic impulse, will the media arts experience a decline of avant-garde work for which the market is likely to remain both small and highly specialized?

Finally, these various developments in the employment opportunities available to media artists and the technology of their creation have democratized the creation of media art. This democratization is reflected in the growing number of artists, their increasingly diverse backgrounds and characteristics, and even

[16]The Security Systems Standards and Certification Act, currently before Congress, would mandate the inclusion of copy-protection technology in all digital devices.

in the process of making art. Indeed, the proliferation of new artists who cross over among media and/or use a variety of media in their work, as well as the increasing tendency for media artists to work with a variety of others, is blurring the traditional distinction among disciplines and media. These trends may indicate a need to redefine what is meant by a "media artist."

ORGANIZATIONS

As we noted in Chapter Two, the organization of the art world is changing in multiple ways. First, the critical role of intermediaries is changing. In addition, the channels used to distribute and market the arts are shifting. Finally, the dimensions along which the arts have traditionally been classified (sector, discipline, and medium) are blurring. How are these trends affecting the media arts?

As we highlighted in our discussion of audiences, a central issue for media artists is how to get their work displayed and distributed. Complicating this process are the many intermediaries between artists and their potential audiences. For example, we have already called attention to the fact that potential distributors of the media arts typically screen narrative and documentary work to assess its audience appeal as well as its overall quality. Similarly, reviews of experimental work affect the marketability of that work. In addition to the screening process, however, artists also rely on intermediaries to help them obtain the resources to produce their work as well as to arrange the distribution, exhibition, and marketing of their finished products. Depending upon the type of work, these tasks involve a variety of different parties—from curators, critics, and independent film producers to media arts centers, foundations, and commercial interests.

Although the challenges this process presents are germane to all artists, especially those who are just starting out or those whose work is not yet recognized, they may be particularly acute for media artists, for three reasons. First, media artists are more likely to lack the institutional resources available to other artists. Second, the market for media arts work is often highly specialized and, given the rapidly changing nature of the work, not well identified or established. Finally, the distribution process itself appears to be changing.

Media artists, for example, are in many ways more like visual artists than performing artists in that they are not generally employed by organizations. Rather, they are likely to work alone or with groups assembled for a specific project. Within the film and video media, for example, narrative and documentary artists work in collaboration with other artists and production crews on individual projects. When the project is completed, the group disbands and its members move on to other work. Installation and computer artists, on the

other hand, may often work alone. As a result, media artists must assume responsibility for many of the functions that arts organizations, e.g., theater or dance companies, typically assume for performing artists. These functions include arranging financing; leasing or purchasing equipment; and arranging for the production, screening, distribution, and marketing of their work. This creates a need for collaborators and intermediaries, such as regional media arts centers, to help individual artists negotiate their way through the various steps required to create, produce, and distribute their art.[17]

In addition, as we have discussed above, distributors assume that most media art work appeals to specialized rather than general audiences. To break this stereotype, media art work needs to be recognized as having a broader appeal. However, as the number of media artists, art forms, and art works proliferates and the works become more diversified and specialized, this may be increasingly difficult to accomplish, for two reasons. First, as the volume and diversity of work grows, the odds against any individual artist's work getting recognized and subsequently screened or exhibited grow longer. Second, as the market becomes more segmented, it becomes more difficult to know which audiences to target and how to identify and reach them.

The pace at which new art forms and practices are proliferating may be a particular problem for the media arts because critics can be slow to accept new artistic styles. As we have already noted, it took several years after the appearance of installation art using media before critics reviewed it and museums (the principal commissioners of these pieces) began to collect it. Similarly, the first Internet-based art was only recently purchased by the Guggenheim Museum (Mirapaul, 2002). Even when a new art form with recognized promise appears (e.g., new forms of interactive narrative art in which the user/participant plays a direct role in determining how the story unfolds), it is likely to raise problems for critics, distributors, collectors, and funders who are uncertain what standards they should use to evaluate such work (Rockefeller Foundation, 2001).[18] This problem is further compounded by the fact that in the United States, at least, critics tend to specialize in one particular medium, discipline, or style.

Finally, the rapid proliferation of new media arts work and its changing technology of production and distribution appear to be challenging existing distri-

[17]As we have noted above, these are the very artists that NAMAC and other media arts service organizations are designed to serve.

[18]This problem also extends to the issue of how to market such work. Consider, for example, the issue of how to market new forms of interactive art in which the user/participant plays a central role in the artistic process. Unlike most narrative or documentary work that is typically presented before a group audience, this type of work is meant to be experienced individually. Should it be marketed like a computer game—with which it shares similarities but whose content may differ greatly? Or should it be marketed like a work of fiction—which usually involves marketing the author as well?

bution models for the media arts. Typically, the distribution process for the media arts (and often other art forms as well) has at least two stages.[19] First, the original work is screened by critics, curators, and potential distributors, who assess its overall quality and its market potential. Second, having selected the work they will distribute, distributors then develop marketing and distribution plans to the presenters who will subsequently display the work.

Since different types of media art are typically displayed in different venues, this process tends to take different forms for different types of media art.[20] The screening process for narrative and documentary work often takes place at festivals designed to preview new work. Subsequently, distribution to theaters, art houses, museum and university film programs, public television, and other sites is handled by distributors who often specialize in particular kinds of venues. Installation and other forms of experimental art depend more on museum curators, art critics, and gallery owners, who are likely to conduct their own marketing programs to attract viewers (museum attendees) or buyers, as appropriate. The process differs somewhat for various forms of computer art, where the display venue is likely to be an individual's computer. Incorporating media arts into museum collections, with all the institutional, logistic, and preservation issues it entails, will be particularly challenging as computer and Internet-based art forms mature. Of course, only a small percentage of the work that is screened is actually distributed commercially.[21]

We lack systematic empirical information on the number and characteristics of the various organizations involved in the screening, distribution, and marketing of the media arts. But the available qualitative information suggests that the distribution process for the media arts is changing as new organizations and informal collaborations proliferate to perform many of the functions that media artists require (Rockefeller Foundation, 2001; NAMAC, 2000a, 2000b). Although these changes offer the promise of wider distribution and more opportunities for media artists to interact directly with their potential audiences, it is unclear whether this promise will be realized.

In recent years, for example, there has been a proliferation of festivals for screening new film, video, and television work. These include not only the traditional film festivals like Cannes, Sundance, Venice, Berlin, and Toronto but also such niche festivals as the British Columbia Student Film and Video Festi-

[19]This is, of course, in addition to the screening of proposals by curators, potential producers (film/documentary), and other funders before a work is even produced.

[20]Once again, the approach in the United States contrasts with that used overseas.

[21]As the figures cited by Gilmore demonstrate, although the number of independent narrative films has skyrocketed over the past few decades, fewer than 10 percent of these films have received any kind of theatrical release.

val, the Austin Gay and Lesbian Film Festival, the Cracow Short Film Festival, the Hispanic Film Festival, and the Student Animation Festival of Ottawa.

In part, the rise in the number of festivals is a result of loss of support for ongoing programs and exhibitions. Arts organizations and other groups are organizing festivals to present a mix of media arts projects, including international film, video, and computer work. Because festivals have lower costs than ongoing programs and can concentrate critics and distributors in one place, they are an attractive way to bring people into a particular venue, attract new audiences, and gain the attention of critics and distributors.

In addition, prospects for broadband transmission and e-commerce may allow media artists to bypass the traditional screening and distribution process and present their work directly to consumers. But, as we have already noted, the proliferation of artists and new material can overload both artists and audiences. For artists, the challenge is how to be heard. For audiences, the challenge is how to identify and locate the material that merits their attention. A number of observers have noted, for example, that this "democratization" of the media arts, while in principle a good thing, inevitably leads to an "exponential replication of junk" (NAMAC, 2000b, p. 14).

Indeed, the democratization of the media arts may well increase the role of critics in determining which works and which artists receive recognition and thus distribution.[22] However, the fact that critics in the United States tend to specialize in particular media or disciplines (again to a greater extent than outside the country) may dilute this critical role.

Technology is also opening up new distribution possibilities. But it is still unclear whether the business models needed to make these technical developments financially practical have been developed, particularly in the aftermath of the collapse of the dot.com boom. Laurel (2001) discusses the challenge of developing and identifying successful business models in the media arts. Even if direct artist-to-audience distribution remains more a promise than a reality, the possibility that digital technology can lower the cost of distribution and enable commercial firms to market successfully to specialized markets has led for-profit firms to enter the market for media arts products (NAMAC, 2000b). Unlike the traditional distributors of media arts works, many of these firms have the technological know-how and, perhaps more importantly, the marketing dollars to promote wider distribution not only of new work but also of existing work that can now be converted into digital format. Indeed, the potential of marketing specialized products to narrowly targeted audiences has prompted

[22]One of our reviewers, for example, suggested that foundations could play a key role in support of the media arts by supporting programs for the development of informed criticism of the media arts.

some firms to begin distributing media arts products like short films—something that was not possible through traditional marketing channels (Miller, 2000).

Once again, several issues must be resolved for the promise of these developments to be realized. First, although the entry of commercial firms into the distribution process may provide significant new resources for marketing media arts work, it is still not clear whether viable business models that will bring a return on that investment have been developed. Media arts distributors, for example, confront many of the same problems dealing with the downloading of copyrighted materials that the recording industry faced with Napster. In addition, it is unclear what marketing approach will be appropriate for interactive narrative and documentary work given its focus on the individual user.

Although for-profit firms may have the resources needed for marketing, they—unlike the traditional media arts distributors—may lack the content needed to sustain viable markets. Indeed, some observers view the competition between the resource-poor but content-rich traditional media arts distributors and the resource-rich but content-poor new commercial distributors with alarm. They are concerned both about how much of the increased spending will end up in the hands of the artists and about the effects of this competition on traditional distributors. They believe that these distributors, who have played a critical role in supplying selected, especially nonprofit, markets, must continue in this role (NAMAC, 2000b). If the traditional distributors disappear, they say, will new commercial distributors like Amazon.com fill this niche, or will the new distributors focus instead on markets that offer higher rates of return? Similar questions have arisen in the recorded music market, where independent distributors and retailers of recorded music appear to be losing out to the major record companies (Stroud, 2000).

Another promise made possible by the new technology is the conversion into the new digital format of the substantial body of existing work that was originally produced in other formats. This would not only ensure access to work that might otherwise be lost, but it could also supply content for distributors.[23] This conversion process, however, will require a significant investment. It is unclear whether the new commercial distributors will be willing to make this investment without first solving some of the distribution and marketing problems we have just discussed.

Although much of this discussion has focused on how technological developments will affect the supply side of the media arts market, there is also concern about what the increasing importance of computer technology will mean for

[23]We return to the issue of preservation in Chapter Five.

individuals and communities without access to this technology. Given the historical concern within the media arts for providing voice to those whose stories have not been covered by the commercial film and broadcast industries, the exclusion of such groups from these new developments would be viewed as inconsistent with the media arts' roots. It would also run counter to the increasing concern within the arts community more generally with providing greater access to the arts to the public at large (American Assembly, 1997).

FUNDING

How these distribution issues are resolved is of central importance to the media arts because they, like the arts more generally, must function within a new and more challenging funding environment. As noted in Chapter Two, individual artists are facing increasing competition for a shrinking pool of grant funds and in all likelihood will have to rely more on their earnings to support their work. Arts organizations face similar pressures to increase their earned revenues in the face of uncertain public funding and a growing tendency for corporations and foundations to channel their support for the arts through restricted categorical funding.

Although we lack solid empirical evidence of how these trends are manifest in the media arts, we have several reasons to assume that both individual media artists and media arts organizations are facing increasing financial pressures. Recent reports by the Rockefeller Foundation's Media Arts program and from the National Alliance for Media Arts and Culture, for example, underscore the financial pressures the media arts are facing (Rockefeller Foundation, 2001; NAMAC, 2000b). By 1996, funding for the NEA's media arts program had plummeted over 90 percent from its peak in 1981.

A recent empirical study of arts funding in New York City is particularly useful in documenting the pressures the new environment is exerting. This study examines recent patterns of financial support in the city by arts discipline and size of organization (Alliance for the Arts, 2001). Because media arts organizations tend to be smaller than museums and performing arts organizations, these data on funding patterns by size of organization may provide special insights into the problems the media arts face.

These New York data, as well as NEA data drawn from the Census of Service Industries, suggest, for example, that visual arts organizations (in which media arts organizations are included) have traditionally been more dependent upon government grants and contributed income than have performing arts organizations (NEA, 1998). Thus, they will be more directly affected by changes in funding practices from these sources.

Furthermore, the data indicate that although large arts organizations receive the lion's share of total government funding, smaller arts organizations are much more heavily dependent upon government funds.[24] For example, although the largest arts organizations in New York City received over half of all the government funds distributed in the city, these funds represented less than 10 percent of their total budgets. In contrast, medium-sized and small arts organizations depended upon government support for between 20 and 28 percent of their revenues. Thus, cutbacks in government funding are likely to have a particularly dramatic effect on the operations of smaller arts organizations, including those in the media arts.[25] Small and medium-sized arts organizations also appear to be at a disadvantage in competing with larger organizations for corporate and individual contributions. In recent years, both corporate and individual donors have increased their contributions to large organizations in New York City while reducing them to small and medium-sized groups (Alliance for the Arts, 2001).

Visual arts organizations, as we have noted, are less reliant on earnings than are their performing arts counterparts. In large measure, this reflects the fact that admissions receipts make up a smaller portion of their total revenue. Given the fact that attendance at art museums has been rising more rapidly than attendance at live performances, this is probably due both to the unwillingness of some museums to charge admission fees and the reluctance of others that do charge to raise their admission prices.[26] Interestingly, however, earnings from sources other than admissions, which as we have noted have been growing faster than admission receipts, are generally a more important source of revenue in the visual arts than in the performing arts (NEA, 1998b). However, the New York City data indicate that the mix of admissions receipts and other earnings varies substantially between large and small arts organizations. Specifically, large organizations' revenues are about evenly divided between admissions and other earnings, whereas medium and small arts organizations' revenues are disproportionately made up of other earnings. We do not know why this is the case, but we do know it does not bode well for media arts organizations that are not only smaller but also less well-established and much more likely to be presenting new and less well-known work.

[24]Very large organizations were defined as those with over $10 million in operating budgets, large organizations were those with budgets between $1 million and $10 million, medium-sized organizations had budgets of between $100,000 and $1 million, and small organizations had budgets of less than $100,000 (Alliance for the Arts, 2001).

[25]Gail Silva made a similar point in her interview with the authors.

[26]This pattern appears to contrast with the policies of many performing arts organizations that have raised their prices for performing arts events.

In addition, media arts funding from the public sector has not fared well in recent years. Cutbacks in federal funding and the resultant shift to state and local government support have placed added burdens on media artists and media arts organizations to find new sources of funds. Although a select few filmmakers and other media artists are capitalized and thus able to support their own work, and others may be able to go through the lengthy National Endowment for the Humanities and foundation granting process (where lead times are often nine months or longer), most cannot afford to depend on government and foundation grants.

At the same time, the tendency of corporations to target larger organizations for support and to rely increasingly on categorical grants has made it more difficult for the media arts to secure funding from this source. Moreover, there is often an antipathy in the media (and other arts) toward the commercial world because of the perception that its system of funding and distribution is unfair and exclusionary.

Foundations, traditionally major supporters of the media arts, have also become increasingly prone to target their support. As a result, the media arts have sought to boost their earned revenues. Yet the scale and nature of their operations often mean that these efforts are directed less to admission receipts and more toward a variety of other activities for which users will pay and programs for which fees can be charged. For example, documentaries seem to be revenue-earners (e.g., Doubletake, California Newsreel). In sum, while there are more opportunities for support today, there is also more competition for those funds.

Perhaps the most promising development in funding for the media arts has been the emergence of what might be termed intermediary organizations that "broker" between the media arts and media artists and potential funders.[27] Examples of this phenomenon include Creative Disturbance, which seeks to foster collaborations between media artists and corporations as a form of corporate research and development, and Creative Capital,[28] which lends money to individual artistic projects for audience development, marketing, and other assistance in exchange for shares of the proceeds generated. The proceeds are then reinvested in the work of other artists. These organizations help bridge the gap between the artistic and funding communities and in the process provide

[27]As one interviewer of the CEO of Creative Disturbance wrote: "Being that us Nader-loving folk like to avoid direct connections to the slaves of shareholder value, several organizations are coming to our rescue by offering to run interference between our artistic side and capitalist guilt" (Mays, 2001).

[28]Creative Capital (http://www.creative-capital.org) is an outgrowth of the Andy Warhol Foundation. It has raised a $5 million endowment fund with donations from individuals and foundations.

the set of skills necessary to secure the recognition and expertise (including business expertise) the media arts need to increase their earnings, where practical. Where increasing earnings is not practical, they can convince corporate and other supporters of the relevance of the media arts to their objectives.

Although there is unlikely to be a single solution to the funding problem, it is clear that the media arts, just as much if not more than the other arts, face a more difficult time raising funds than they have in the past.

CONCLUSIONS

The previous chapters have defined the media arts, described their development, and discussed how they differ both from each other and from other art forms. In this final chapter, we assess the overall state of the media arts today, identify some of the major challenges facing the media arts, and suggest some steps that might be taken to meet these challenges.

THE MEDIA ARTS TODAY

We do not possess enough empirical data to draw a definitive picture of the media arts. Nevertheless, available information suggests that any such assessment would likely yield a mixed picture. In some respects, the media arts are clearly thriving; in others, the picture is less positive. The discussion that follows presents our views of the current state of the media arts. We begin by highlighting the most positive features and then discuss more problematic features.

From an artistic perspective, the media arts are flourishing. During the past decade there has been a proliferation of new ideas, new formats, and new work. In addition, the continued development and application of digital technology to the arts is allowing artists to integrate text, photography, video, graphics, and sound in entirely new ways, creating a whole new aesthetic in the process (Manovich, 2001a). Digital technology has opened up the possibilities of restoring and retrieving significant works from the past by converting them into digital form. It has also made possible new art forms like web art and interactive narrative, documentary, and experimental art, whose implications are being felt not only in the media arts but throughout the arts world (Landi, 1997). Indeed, the process of experimentation that has always been a feature of the media arts is perhaps more apparent today than ever.

The growing number of media artists and the diversity of their backgrounds are additional evidence of the vitality of the media arts. These developments are providing the increasingly wider perspective that the media arts have long

sought. In addition, the growing number and range of collaborations between media artists and the scientific, research, and commercial sectors have greatly expanded the employment and earnings options for artists. In the process, the techniques developed in the media arts are influencing other fields like science and architecture, as well as the arts and American culture more generally (Lunenfeld, 2000a, 2000b).

The media arts are also well positioned to benefit from changes in the ways Americans are experiencing the arts and in how the arts are being distributed. The growing tendency for people to participate in the arts through the media as well as their apparent penchant for choosing leisure pursuits that they can experience when and where they want, for example, augur well for the media arts.

In addition, economic and technological trends that have made servicing specialized or niche art markets feasible should benefit the media arts, which have traditionally been regarded as better suited to specialized rather than general audiences. The proliferation of festivals at which media arts works are screened and the fact that museums are increasing their collections of installation art and are beginning to collect Internet art suggest that there is increasing interest in media arts works, including experimental works. An increasing number of independent narrative films are reaching wider audiences, and new distribution channels, e.g., microcinemas, are benefiting those that are not (Bachar and Lagos, 2001). There is also evidence that these developments have revived the market for products, e.g., short films, that are no longer distributed through traditional channels (Miller, 2000).

Although the promise of e-commerce and distribution through the Internet remains to be demonstrated conclusively, there is a growing use of the Internet for obtaining information and purchasing artistic programming. This change in behavior is increasing demand for content. The media arts are well positioned to meet this demand. In sum, the media arts, unlike the performing and visual arts, are uniquely well suited to taking advantage of expanding channels for distributing the arts, especially to specialized audiences.

In other respects, however, the picture is less rosy. Despite the increasing range of employment and earnings options, there is little firm evidence that media artists (or other artists for that matter) are better able to support themselves exclusively through their art than they have been in the past. Indeed, many of the new opportunities available for artists using digital technology involve nonartistic uses of that technology.

Moreover, the challenges both individual media artists and media arts organizations face in seeking financial support for their work appear to have increased. Government funding, especially federal funding, for the media arts

has declined. At the same time, corporate and foundation support for the arts in general has been increasingly linked to how specific arts projects serve the objectives of those organizations. Moreover, the evidence suggests that media arts organizations, given their size and the type of work they do, are at a disadvantage when competing with other arts organizations for the support available.

Indeed, it appears that media arts organizations, like other arts organizations, will increasingly look to the market and to earned income to support their activities. Because of the nature of their operations, however, they are less likely to increase admission receipts than to look to other kinds of marketing activities and fee-producing programs to supplement their budgets. Moreover, given the nature of the market for some types of media arts work, e.g., experimental work, some media artists and the organizations that support them are likely to continue to rely upon the contributions and grants on which the nonprofit sector has traditionally depended. But the type of entrepreneurial skills that are best suited for the new type of marketing may well be foreign to those media artists and administrators who still view the commercial distribution of independent films with some suspicion. Although the anticommercial sentiment that once characterized the media arts has moderated substantially, the media arts still need to develop entrepreneurial skills relevant to the current funding environment. The emergence of a new set of brokers or intermediaries, such as Creative Capital and Creative Disturbance, may, however, help supply this expertise.

In addition, although there appears to be substantial potential for audience growth for the media arts, that potential has not yet been realized. In large part, this appears to be a product of the reliance of media arts on distributors and critics who continue to play a critical role in determining how and why some art is distributed. Indeed, the very proliferation of new media art could well increase the importance of intermediaries who may either base their judgments on outdated images of what the media arts have to offer or lack the background to assess the artistic merit of the work. While the proliferation of new distribution channels can offer new ways for media artists to interact with their audiences, taking advantage of these opportunities may require a better knowledge of who those audiences are. Indeed, despite media artists' concern with increasing distribution and access to their work, the media arts community has not yet taken the initial analytical steps to develop a clear sense of its audiences, how they differ for different types of media art, or how these audiences gain access to the media arts.

CHALLENGES FACING THE MEDIA ARTS

Despite their artistic vitality and their potential to take advantage of changing audience and distribution patterns, the media arts community, like the art

world more generally, faces a series of challenges for which they may not be prepared. These challenges fall mainly into five areas: distribution, funding, understanding the public benefits of the arts, preservation, and developing a clearer identity and greater visibility for the art form.

Distribution

Media artists need to address two distributional issues. The first relates to getting more exposure to their work and broader audiences for it. The second concerns the many policy issues surrounding new distribution technologies.

Media artists, like other artists, do not generally deal directly with their audiences. Rather, they are dependent upon intermediaries both to review (and thus advertise) and to market and distribute their work. Indeed, this dependence may actually be increasing given the proliferation of new media arts works. Although new distribution channels offer opportunities for direct distribution to consumers, they will not alleviate the need to inform consumers about what is available and what the media arts have to offer. How to provide this information and improve access to the media arts will be a central challenge.

To develop audiences, the media arts field needs to consider not only new marketing and advertising strategies but also the impact of critical reviews of media arts work. For example, creative partnerships (such as *Time Out*'s support of art exhibitions in New York or Target's support for public arts projects) and product placements and promotions might raise the visibility of the media arts, particularly with younger audiences. With regard to criticism and reviews of the media arts in the press, one strategy might involve media arts organizations or funders finding ways to support critical writing and its dissemination.[1]

In addition, how the new distribution channels and technologies will be used hinges upon the resolution of a key set of policy issues. These issues include what governmental policies will be adopted with regard to copyright protections, what business models (including the share of earnings media artists receive for their work) will be developed and applied to these new distribution channels, how the new interactive media will be marketed and distributed, whether a new, faster Internet channel will be created, and, if so, who will have access to it.[2]

[1]We thank John Hanhardt for his comments on the role of advertising and criticism for future development of audiences.

[2]This new Internet channel is sometimes referred to as "Internet 2." It would presumably be much faster and more powerful than the current Internet. Who will have access to it and for what purposes are likely to be major issues in the future (NAMAC, 2000b).

How these policy questions are resolved will affect a host of private and public interests, and it is important that the perspectives and interests of media arts organizations and media artists be incorporated into these decisions. For that to occur, however, the media arts need to be recognized as having a legitimate interest in the debate. This, in turn, will require the media arts community to be better organized, to develop a position on these issues, and to make the public and decisionmakers aware of the important role the media arts play in the development and use of these technologies.

Funding

The challenge of dealing with the current funding predicament in the media arts will require not just increased funding but also diversification of funding sources. Diversification is important both to avoid problems from a sudden drop from a particular source (e.g., NEA support for the media arts in 1997) and because some funding sources are better suited to specific branches of the media arts. For example, experimental works are less apt to be supported by admissions receipts than narrative work. New media art may be able to tap into funding for emerging technologies that, say, video art might not. A key challenge is to recognize that the multifaceted approach media artists have already pursued may involve an even wider array of funding sources and strategies.

A prerequisite for such an approach is the need for people in the media arts community to view financial support not simply in terms of its impact on media artists and arts organizations but, just as important, in terms of how their art promotes the public interest and accords with the objectives of the diverse array of potential funders.

Public Benefits

This prerequisite raises a third issue for the media arts. In an increasingly competitive funding environment, both public and private funders have become more concerned with the public purposes of the arts. In their funding strategies, for example, governments and foundations have focused increasing attention on promoting the public benefits of the arts (American Assembly, 1997; Cherbo and Wyszomirski, 2000). As we have noted elsewhere (McCarthy et al., 2001), the arts can support the public interest by

- providing entertainment, enrichment, and fulfillment for individuals

- serving as a vehicle for the preservation and transmission of culture

- providing a variety of instrumental benefits for society at the individual, community, and national levels.

The media arts community needs to articulate how it supports these goals. In considering individual-level benefits, it needs to consider not just the number but also the range of individuals who benefit. Given media arts organizations' traditional focus on expanding the diversity of perspectives they represent, this is a goal with which many are already familiar. The latter two goals, however, appear to have received more attention from the media arts community abroad than in the United States.

In particular, those in the field should explicitly consider not just the intrinsic value of the media arts but also their instrumental or indirect benefits.[3] At the individual level, for example, the media arts may promote an openness to new ideas and creativity as well as competency at school and work. At the community level, they can provide a variety of social and economic benefits, such as increasing the level of economic activity, serving as sources of innovation, and supporting the development of creative industries. At the national level, they can promote an understanding of diversity and pluralism and provide a source of the nation's exports. Moreover, they have played and continue to play a central role in American culture. By demonstrating and documenting how the media arts promote such benefits to the wider community, those in the field can make a stronger case for financial support.

In contrast, corporate supporters of the arts are often most interested in how their funding connects with their business plans. This means that corporations focus not necessarily on how such funding affects their bottom line but rather on how it relates to their image within the community, improves their ability to connect with particular market segments or populations, promotes the livability of communities, or enhances the development of new products (Cobb, 1996). The increasing range of collaboration between media artists, especially digital artists, and the corporate sector, as well as the emergence of institutions that broker between media artists and business, may enhance the opportunities for the media arts in this sector. In these activities, the media arts in the United States could benefit from the example of their counterparts abroad.

Individual contributions are the fastest growing source of support for the arts. Increasingly, however, that support comes not from a few major patrons of the arts but from an expanding number of individuals who give smaller amounts to the specific institutions with which they are involved. The keys here are likely to be broadening the range of participants who are involved in their activities and developing relationships between media arts organizations and their audiences. Given the increasing interest in "hands-on" participation among Ameri-

[3]This assertion is not meant to deny or demean the value of art for art's sake. Rather, it is based on our belief that these indirect effects are of considerable importance to the behavior of individuals and institutions the media arts would like to influence.

cans and the robust growth of the volunteer arts sector (McCarthy et al., 2001), this is an area to which those involved in the media arts might give more attention—particularly given the increasing importance that information technologies are playing in contemporary arts and culture.

Preservation and Technical Obsolescence

Given the importance of experimentation in the media arts and their rapid adoption of technological innovation, as well as use of ephemeral media (e.g., videotape, interactive Internet art), a major issue for the media arts, unlike the other arts, is how to preserve works done using formats, equipment, and computer code that may no longer be available. Access to earlier work in the media arts is not simply of historical interest since, as we noted above, the preservation and transmission of culture is one of the key ways in which art serves the public interest. Moreover, access to some work, such as video art, undermines preservation efforts—in the words of one museum director with a large video art collection, "The more you look at it, the more it goes away."[4] For some net art pieces that exist in a dynamic form, changing from moment to moment based on interactions with users or other data sources, the issue is what to preserve. For example, the Guggenheim's acquisition of several digital art works involves not only collecting the code but also daily archiving of all site data.[5]

Increased Visibility

Finally, one of the major challenges facing the media arts is their lack of visibility. The media arts literature, for example, devotes more attention to the individual media (film, video, and computers) used in the production of the media arts than to the media arts as a distinct art form. Indeed, there is considerable dispute among media artists as to how to define and label the media arts (Jennings, 2000). Moreover, there does not seem to be an agreed-upon vocabulary for describing the field. While this situation may be understandable for an art form still in its youth, its consequences may not be benign. Without a sense of the media arts as a distinctive genre, for example, arts funders may be less likely to provide funding programs for media artists and media arts organizations. Similarly, the public—both as consumers and as potential contributors—will be less aware of the media arts. As we noted earlier, NAMAC's strategic plan has explicitly recognized the importance of this challenge.

[4]Nelson, interview at Long Beach Museum of Art, June 26, 2002. His reference is to the fragility of the original videotapes, which increases as they age and are used.

[5]Mirapaul (2002).

RECOMMENDATIONS

It may not be surprising—given the media arts' youth, their tendency to incorporate changing technology, and the rapidly changing nature of artists' practices—that our assessment of the strengths of the media arts emphasizes their artistic vibrancy and their potential to benefit from changes in demand associated with technological changes in the distribution of the arts.

Nor, in contrast, is it surprising that our assessment of their weaknesses focuses on issues relating to the media arts' organization and public visibility. For example, we have repeatedly noted that the media arts lack a clear identity as a distinctive art form—a finding that is reflected in the literature, which emphasizes individual artistic practice rather than those elements that are common to the media arts as a whole. It is also reflected in the fact that media artists often cannot agree on how to label themselves or how to define the media arts. Finally, it is reflected in what we believe is a lack of public understanding of what the media arts are and how they differ from the products of other organizations and individuals who work with film, video, and computers.

We believe this lack of clarity makes it more difficult for the media arts to surmount the challenges of a changing arts environment. In the discussion below, we highlight four steps those in the media arts might take to deal with these issues.

1. The media arts community needs to develop a clearer sense of identity if it believes, as we do, that the media arts represent more than simply the sum of their individual parts. Developing this identity will require a clearer vocabulary for defining and describing the media arts to those outside the field. This, in turn, will first require media artists and media arts organizations to agree on these issues. Those in the field also need to promote a clearer public understanding of what the media arts are and how media artists differ from their commercial counterparts who work with film, video, and computers. Although these distinctions may be self-evident to the media arts community, it is not clear they are to others.

2. The media arts community needs to be more attuned and responsive to the policy context in which it operates. In other words, it needs to take an active role in public debates about the regulatory issues that will govern the use of technology in providing arts and entertainment and to devote more explicit attention to the public benefits the media arts provide. Documenting these benefits and showing how limited access to the media arts affects these public benefits will not only provide a stronger rationale for support of the media arts but will also increase their public visibility.

3. Media artists and organizations should attempt to broaden public involvement in their activities. This includes broadening and diversifying the audiences for the media arts but certainly should not be limited to those activities. As we have noted elsewhere (McCarthy and Jinnett, 2001), arts organizations have multiple missions, and the priority they assign to the various missions differs.[6] Media arts organizations need to consider how to increase public participation in terms of their own missions and goals. This will require them to select their target audiences and collect information about them. Using good information about these potential audiences, they can then develop tactics to engage them. Knowing something about potential participants' levels of interest toward the arts and the kinds of art they are interested in; their lifestyles, information channels, and resources; and the kinds of benefits (individual and social) they are seeking will help artists and organizations design effective tactics to reach them (McCarthy and Jinnett, 2001). However, such information does not currently exist and most organizations do not have the capacity to collect it. Media arts funders might assist by requiring audience information in their grantmaking criteria or by funding arts organizations or others to develop these capabilities.

4. Finally, the media arts community needs to address the lack of systematic information about the field as a whole—not only about audiences, but also about artists, organizations, and funding.[7] The challenges in collecting such information are significant and are intertwined with several other challenges facing the field. The lack of a common understanding and definition of the media arts, for example, poses problems for information collection efforts. In addition, the current funding climate makes it less likely that scarce resources will be devoted to meeting these information needs. But the absence of information on the media arts complicates efforts to understand how they operate and increases the chances that decisions about the various issues and challenges facing the media arts will be based on incomplete or erroneous information.

[6]Our earlier work identified, for example, at least three different purposes of arts organizations: promoting the canons of specific art forms, focusing on serving specific communities of interest, and promoting creativity. Although these goals are certainly not mutually exclusive, most of the organizations we are familiar with have tended to assign their highest priority to one of these goals.

[7]Once again, NAMAC's explicit attention to these information issues is a step in the right direction.

INFORMATION ON THE MEDIA ARTS

There is a growing body of literature on the media arts—especially since the proliferation of digital or computer art forms. This appendix outlines our search methods, gives an overview of the literature on the media arts, highlights the problems we found in the literature, and elaborates upon suggestions made in the body of the report for improvement.

SEARCH STRATEGY

Given the nature of this literature discussed previously, we used a complex search strategy that employed a wide variety of sources. These sources included literature compiled as part of RAND's Comprehensive Assessment of the Arts, searches of a variety of computer databases on the arts (including books in and out of print, book reviews, items catalogued by the Library of Congress, conference proceedings, NEA materials, and articles in arts and humanities journals), relevant arts journals, references from other sources, weekly searches of newspapers and periodicals, web sites, and referrals given to us by individuals we interviewed during the course of our research. In reviewing each of these sources, we used a variety of search terms to identify items that were likely to be of interest.

This search process yielded 2,168 items—about 20 percent of which were duplications. We then looked more carefully at abstracts and descriptions of these items to determine which ones were likely to be most useful. This second stage yielded approximately 530 items, which we then reviewed individually. Of these items, approximately 200 were judged to be most useful for our analysis, about 75 of which are included in this report.

CHARACTERISTICS OF THE LITERATURE

As the report notes, the literature on the media arts can be divided into work that was written before the emergence of digital art (around 1990) and work

written since. Before the advent of digital art, the media arts were dominated by film, video, and installation art using film or video. The literature of this period is primarily historical and conceptual in nature. It contains profiles of individual artists and exhibits; histories of the development of these media and the artistic styles and techniques used by film, video, and installation artists; and a wide variety of volumes that provide practical guidance for individual media artists. The literature of the post-digital period is also heavily weighted with reviews of individual artists and their work, discussions of the evolution of digital art forms, and instructional manuals. However, it is more likely to be found on-line, in exhibition catalogues, and embedded in reviews than in books, journals, or scholarly papers.

Considered as a whole, the literature on the media arts has several distinctive features:

- It is much more likely to focus on the individual media arts disciplines than it is to treat the media arts as a distinctive arts genre. As a result, there is a general absence of work that compares and synthesizes what we know about each of the disciplines and what they imply about the media arts as a whole.

- The literature is much more likely to discuss the artistic and aesthetic aspects of the media arts disciplines than it is to examine their organizational features. Thus, much of this work emphasizes the development of particular artistic styles rather than the size and characteristics of the audiences; the employment and background characteristics of media artists; or the number and characteristic of organizations that produce, distribute, and fund the media arts.

- There is very little empirical information available about the media arts, especially in comparison with the data available about the performing, visual, and literary arts. For these art forms, we have such information as rates and frequency of public participation by discipline, the characteristics of participants, the number and earnings of artists, the size and revenues of arts organizations, and their earnings and other sources of funding. No such data exist for the media arts.

- We have described the literature on the media arts as "fugitive." That is, it is scattered across many types of sources, including newspapers and magazines, academic journals, exhibition catalogues, and on-line sites. Many of these sources may never be recorded in standard bibliographic databases. Moreover, much of this work is classified according to the individual discipline to which it pertains rather than the media arts per se, making it relatively inaccessible to those seeking to compare patterns for the media arts as a whole.

PROBLEMS WITH EXISTING DATA

Indeed, even when data do exist that might otherwise be used to provide empirical information about the media arts, those data are not collected or reported in a form that allows such comparisons. For example, although the Survey of Public Participation in the Arts (SPPA), sponsored by the National Endowment for the Arts, collects a wide range of information about arts participation, including attendance at films and art museums, we cannot use these data to examine participation patterns in the media arts because they employ categories to describe art forms that do not conform to those used in the media arts. The SPPA data on film attendance, for example, do not distinguish among narrative, documentary, and experimental films, nor do they distinguish between independent and commercial films. Thus, the fact that two-thirds of American adults attended a film in the past year does not tell us how many of them attended, for example, independent narrative films, documentaries, or experimental films.

Similarly, although the SPPA contains information on museum attendance, where many media arts pieces are displayed, it contains no information on the objects (e.g., video art, installation art using media) that attendees view. Finally, although the latest version of the SPPA specifically asks respondents about their use of personal computers for the arts, these data cannot relate personal computer usage to involvement in the media arts. For example, the lead question about personal computer usage asks whether respondents used their personal computers to participate in any art form. Although the reported usage (8 percent) is relatively low when compared with attendance at live performances (42 percent), it compares favorably with rates of personal (e.g., "hands-on") participation in the arts. In addition, about 9 percent of the respondents used their computers to obtain information about events or tickets. Forty percent of all respondents indicated that they used their computers for hobbies (e.g., games, surfing the web), suggesting that personal computers are becoming an increasingly important tool in individuals' leisure activities (NEA, 1998a).

Similar problems exist in the Population and Economic Census with regard to information collected on artists and arts organizations. The Population Census collects a considerable variety of data on artists, including their education, training, employment, and earnings. However, the categories it uses to sort artists (performing artists, actors, directors, dancers and musicians, visual artists, graphic artists, etc.) fail to identify media artists and thus cannot be used to compare how these characteristics vary either across the media arts or between media artists and other artists. The classification of arts organizations in the Economic Census is somewhat more useful but still too selective to provide a comprehensive description of the arts organizations involved in the production and distribution of the media arts.

As a consequence, we have little empirical information with which to describe the various structural components of the media arts. There is almost no empirical data, for example, on the audiences for the media arts in general—much less how on these audiences might differ across the different forms of the media arts. Similarly, despite the abundance of articles on individual artists in the literature, we know little about how the employment circumstances and backgrounds of these artists vary across the media arts or compare with those of artists in other fields. The same situation exists with regard to information on media arts organizations. For example, although the literature contains information about individual media arts organizations, these studies typically emphasize the particular challenges and histories of specific organizations and cannot be used to draw a profile of the organizational structure of the media arts and how it might differ from other arts genres. Finally, although one finds many references to the need for more funding of the media arts and suggestions for finding existing funding (e.g., Jennings, 2000; NAMAC, 2000), we lack systematic historical information on the amount of funding for the media arts, its sources, or how it may have changed over time.

This situation is understandable given the relative youth and diversity of the media arts. However, it poses a real challenge to a comprehensive assessment of their current state and how the media arts compare with the more established performing and visual arts. Clearly, more attention needs to be devoted to developing common standards for collecting systematic data about the media arts. At a minimum, this effort will require a common definition of the media arts and the ways to classify them. Currently, as noted, the media arts are sometimes defined in terms of the various subdisciplines or artistic approaches used by media artists, other times by the technology used to produce them, and still other times by the different functions they serve. A typical example of this situation is the categories used by the National Endowment for the Arts to report its funding of the media arts. Prior to 1997, the NEA grouped its grants under a media arts category. After 1997, it eliminated the media arts category altogether when it reorganized grantmaking along functional lines (education, preservation, partnerships, etc.). Similar problems exist among media artists themselves, who often fail to agree on the terminology they use to describe their work (Rockefeller Foundation, 2001). This situation makes it almost impossible to develop common standards for collecting and organizing data about them, much less for media artists to view themselves not simply as artists working with film, video, or computers, but also as part of a larger group of media artists.

WHAT CAN BE DONE TO IMPROVE THIS SITUATION?

In the absence of such agreement, however, there are steps that can be taken to improve existing data collection. As we have already noted, current survey data

such as that collected by the NEA in its Survey of Public Participation in the Arts, by the Census Bureau's Population and Economic Census, and in the reporting of organizational data by the IRS, could be made much more useful by changing the categories used to organize and report the data. Funders of the media arts could play a particularly useful role in this process by explicitly recognizing the media arts as a separate category for their grantmaking. This practice would encourage the various categories of media artists to recognize that their work falls within the larger media arts genre. In addition, a host of institutions, such as museums, film festivals, and funders, regularly collect information on such aspects of the media arts as attendance, number of films reviewed or exhibited, or dollars spent. By using a common set of standards to define the information they collect and report, these organizations could provide a useful source of information on the media arts.

INTERVIEWS

Ken Breecher
Executive Director
Sundance Institute

Kathy Brew
Director
Thundergulch

Sara Diamond
Artistic Director, Media Visual Arts, and
Executive Producer, TV & New Media
The Banff Centre for the Arts

Steve Dietz
Director, New Media Initiatives
Walker Art Center

Jean Gagnon
Director of Programs
The Daniel Langlois Foundation

Geoffrey Gilmore
Director of Film Festival Programming
Sundance Institute

Carl Goodman
Curator of Digital Media
American Museum of Moving Image

John Hanhardt
Senior Curator of Film & Media Arts
Guggenheim Museum

Jon Ippolito
Associate Curator of Media Arts
Guggenheim Museum

Carol Joins
Director of the Center for Public Policy and the Arts
University of Chicago

Barbara London
Associate Curator, Department of Film and Video
New York Museum of Modern Art

Peter Lunenfeld
Director
Institute for Technology and Aesthetics

Hal Nelson
Executive Director
Long Beach Museum of Art

Anne Pasternak
Executive Director
Creative Time

Peter Ride
Artistic Director
DA2 Digital Arts Development Agency

Lawrence Rothfield
Acting Director, Cultural Policy Program
University of Chicago

Michele Satter
Director of Feature Films
Sundance Institute

Joan Shigekawa
Associate Director, Creativity & Culture
Rockefeller Foundation

Gail Silva
Executive Director
Film Arts Foundation

James A. Smith
Board of Directors
Creative Capital Foundation

Carol Stakenas
Associate Director
Creative Time

Louise Stevens
President
ArtsMarket

Mark Tribe
Executive Director
Rhizome Communications

Sara Tucker
Director of Digital Media
Dia Center for the Arts

Benjamin Weil
Curator of Media Arts
San Francisco Museum of Modern Art

Jim Yee (deceased)
Director
Independent Television Services

"1992 NEA Grants to Media Arts Centers," *Afterimage*, Vol. 19, No. 8, March 1992.

"1992 NEA Grants to Media Arts Centers," *Afterimage*, Vol. 19, No. 9, April 1992.

Albanese, Andrew, "Copyright Term Goes to High Court," *Library Journal*, No. 5, March 15, 2002, http://libraryjournal.reviewsnews.com.

Alliance for the Arts, *Who Pays for the Arts? Income for the Nonprofit Cultural Industry in New York City*, New York, 2001.

Alper, Neil O., and Gregory H. Wassall, *More Than Once in a Blue Moon: Multiple Jobholdings by American Artists*, National Endowment for the Arts, Santa Ana, CA: Seven Locks Press, 2000.

Alper, Neil O., Gregory H. Wassall, Joan Jeffri, et al., *Artists in the Work Force: Employment and Earnings 1970 to 1990*. NEA Research Division Report No. 37, Washington, DC: National Endowment for the Arts, 1996.

American Assembly, *The Arts and the Public Purpose*, final report of the 92nd American Assembly, New York: Columbia University, 1997, pp. 64–70.

American Cinematographer, "The State of Independents," *American Cinematographer Special Section*, March 1996.

Antin, David, "Video: The Distinctive Features of the Medium," in John Hanhardt, ed., *Video Culture: A Critical Investigation*, Layton, UT: Peregrine Smith Books, 1986.

Aufderheide, Patricia, "Public Intimacy: The Development of First Person Documentary," *Afterimage*, Vol. 25, No. 1, July–August, 1997.

Bachar, Joel S., and Taso Lagos, "The Exhibition Revolution: Coming Soon to a Micro Cinema Near You!" *Moviemaker*, No. 41, Winter 2001, http://www.moviemaker.com/issues/41.

Balfe, Judith H., "The Baby-Boom Generation: Lost Patrons, Lost Audience?" in Margaret J. Wyszomirski and Pat Clubb, eds., *The Cost of Culture: Patterns and Prospects of Private Arts Patronage*, New York: ACA Books, 1989.

Balfe, Judith H., and Monnie Peters, "Public Involvement in the Arts," in Joni Cherbo and Margaret J. Wyszomirski, eds., *The Public Life of the Arts in America*, New Brunswick, NJ: Rutgers University Press, 2000, pp. 81–107.

Baumol, William J., and William G. Bowen, *Performing Arts—The Economic Dilemma: A Study of Problems Common to Theater, Opera, Music, and Dance*, New York: The Twentieth Century Fund, 1966.

Benjamin, Walter, "The Work of Art in the Age of Mechanical Reproduction," in John Hanhardt, ed., *Video Culture: A Critical Investigation*, Layton, UT: Peregrine Smith Books, 1986.

Bodow, Steve, "The Whitney's Digital Sampler," *New York Magazine*, March 26, 2001.

Boyle, Diedre, "A Brief History of American Documentary Video" in Doug Hall and Sally Jo Fifer, eds., *Illuminating Video: An Essential Guide to Video Art*, San Francisco: Aperture, in association with the Bay Area Video Coalition, 1990.

Bruzzi, Stella, *New Documentary: A Critical Introduction*, London: Routledge, 2000.

Bullert, B. J., *Public Television: Politics and the Battle over Documentary Film*, New Brunswick, NJ: Rutgers University Press, 1997.

Butsch, Richard, *The Making of American Audiences: From Stage to Television, 1750–1990*, Cambridge, UK: Cambridge University Press, 2000.

Camper, Fred, "Cinema's Phoeny: Deaths and Resurrections of the Avant-Garde," in conference proceedings, International Experimental Film Congress (Toronto), Art Gallery of Toronto, 1989.

Cave, Damien, "Chained Melodies," *Salon.com*, March 13, 2002, www.salon.com/tech/features.

Caves, Richard F., *Creative Industries*, Cambridge, MA: Harvard University Press, 2000.

Century, Michael, *Pathways to Innovation in Digital Culture*, Centre for Research on Canadian Culture Industries and Institutions, Montreal: McGill University, 1999.

Cherbo, Joni M., and Margaret J. Wyszomirski, "Mapping the Public Life of the Arts in America," in Joni M. Cherbo and Margaret J. Wyszomirski, eds., *The*

Public Life of the Arts in America, New Brunswick, NJ: Rutgers University Press, 2000.

Cobb, Nina K., *Looking Ahead: Private Sector Giving to the Arts and the Humanities,* Washington, DC: President's Committee on the Arts and the Humanities, 1996.

D'Agostino, Peter, ed., *Transmission: Theory and Practice for a New Television Aesthetics,* New York: Tanam Press, 1985.

Davis, Douglas, *Art and the Future: A History/Prophecy of the Collaboration Between Science, Technology, and Art,* New York: Praeger Publishers, 1973.

Davis, Douglas, and Allison Simmons, eds., *The New Television: A Public/Private Art,* Cambridge, MA: The MIT Press, 1977.

DiMaggio, Paul J., "Decentralization of Arts Funding from the Federal Government to the States," in Stephen Benedict, ed., *Public Money and the Muse: Essays on Government Funding for the Arts,* New York: W.W. Norton & Company, 1991.

Druckrey, Timothy, ed., *Ars Electronica: Facing the Future,* Cambridge, MA: The MIT Press, 1999.

Feaster, Felicia, "Chasing Reality, the New Documentary Aesthetic," *Art Papers,* Vol. 22, September–October 1998.

Furlong, Lucinda, "Notes Toward a History of Image-Processed Video, " *After-Image,* Vol. 11, Summer 1983.

Gill, Johanna, *Video: State of the Art,* New York: Rockefeller Foundation, 1976.

Gilmore, Geoffrey, "Long Live Indie Film: Reports of Its Demise Are Exaggerated," *The Nation,* April 2, 2001.

Green, Ronald J., "Film and Video: An Institutional Paradigm and Some Issues of National Policy," *Journal of Cultural Economics,* 1984.

Gunn, Timothy, "The Effects of New Technologies on Independent Film and Video," in Timothy Gunn, ed., *Intellectual Property Right in the Making and Distribution of Films,* conference proceedings, 1996.

Halleck, Dee Dee, *Handheld Visions: The Impossible Possibilities of Community Media,* New York: Fordham University Press, 2002.

Hanhardt, John G., "De-Collage/Collage: Notes Towards a Re-examination of Video Art," in Doug Hall and Sally Jo Fifer, eds., *Illuminating Video: An Essential Guide to Video Art,* San Francisco: Aperture, in association with the Bay Area Video Coalition, 1990.

____, *The Worlds of Nam June Paik*, New York: Guggenheim Museum Publications, 2000.

Hanson, Eric, "Digital Fiction: New Realism in Film Architecture," *Architectural Design*, No. 143, 2000.

Huffman, Kathy Rae, "Video Art: What's T.V. Got to Do with It?" in Doug Hall and Sally Jo Fifer, eds., *Illuminating Video: An Essential Guide to Video Art*, San Francisco: Aperture, in association with the Bay Area Video Coalition, 1990.

Iles, Chrissie, *Into the Light: The Projected Image in American Art, 1964-1977* (Whitney Museum publication), New York: Harry Abrams, 2001.

Ippolito, Jon, http://www.guggenheim.org/internetart/welcome.html.

Jeffri, Joan, *Information on Artists II*, New York: Research Center for Arts and Culture, Columbia University, 1998.

Jennings, Pamela, "New Media/New Funding Models," report prepared for Creativity & Culture, Rockefeller Foundation, December 2000.

Kelly, John R., and Valeria J. Freysinger, *21st Century Leisure: Current Issues*, Boston: Allyn & Bacon, 2000.

Kimmelman, Michael, "Creativity, Digitally Remastered," *The New York Times*, March 23, 2001, p. E3.

Kisil, Gerry, "Technologies of Abundance: Consumer Culture: Government and the Media Arts," *Parachute*, Vol. 84, October–December 1996.

Kluever, Billy, Julie Martin, and Barbara Rose, eds., *Pavilion: Experiments in Art and Technology*, New York: E.P. Dutton, 1972.

Kreidler, John, "Leverage Lost: The Nonprofit Arts in the Post-Ford Era," *Journal of Arts Management, Law, and Society*, Vol. 26, No. 2, 1996, pp. 79–100.

Landes, David S., *The Wealth and Poverty of Nations*, New York: W.W. Norton & Company, 1998.

Landi, Ann, "Material Developments," *ARTnews*, Vol. 96, November 1997.

Laurel, Brenda, *Utopian Entrepreneur*, Cambridge, MA: The MIT Press, 2001.

Lessig, Lawrence, *The Future of Ideas*, New York: Random House, 2001.

Levine, Lawrence W., *Highbrow/Lowbrow: The Emergence of Cultural Hierarchy in America*, Cambridge, MA: Harvard University Press, 1988.

Litman, Jessica, "Revising Copyright Law for the Information Age," *Oregon Law Review*, Vol. 75, No. 19, 1996.

Lovejoy, Margot, *Postmodern Currents: Art and Artists in the Age of Electronic Media*, Englewood Cliffs, NJ: Prentice Hall, 1992.

Loveless, Richard, *The Computer Revolution and the Arts*, Tampa, FL: University of South Florida Press, 1989.

Lunenfeld, Peter, *The Digital Dialectic: New Essays on New Media*, Cambridge, MA: The MIT Press, 2000a.

____, *Snap to Grid: A User's Guide to Digital Arts, Media, and Cultures*, Cambridge, MA: The MIT Press, 2000b.

Lyman, Rick, "Animation's New Bag of Tricks: Cheaper, Faster and More Like Real Life," *New York Times*, June 13, 2000, p. E1.

MacDonald, Scott, "Avant-Garde Film: Cinema as Discourse," *Journal of Film and Video*, Vol. 40, No. 2, Fall 1988, pp. 33–42.

Manovich, Lev, *Post-Media Aesthetics*, http://www.manovich.net, 1999.

____, *Avant-Garde as Software*, http://www.manovich.net, 2001a.

____, *The Language of New Media*, Cambridge, MA: The MIT Press, 2001b.

____, *New Media from Borges to HTML*, http://www.manovich.net, 2002.

Marvin, Carolyn, *When Old Technologies Were New: Thinking About Electric Communication in the Late Nineteenth Century*, New York: Oxford University Press, 1988.

Matsumoto, Neil, "Indies on the Internet," *American Cinematographer*, Vol. 81, December 2000.

Mays, Matt, "Interview with Creative Disturbance," *Switch*, No. 17, February 2001, http://switch.sjsu.edu/v6n2/articles/mays-creative.html.

McCarthy, Kevin F., Arthur Brooks, Julia Lowell, and Laura Zakaras, *The Performing Arts in a New Era*, Santa Monica, CA: RAND, MR-1367-PCT, 2001.

McCarthy, Kevin F., and Kimberly Jinnett, *A New Framework for Building Participation in the Arts*, Santa Monica, CA: RAND, MR-1323-WRDF, 2001.

Miller, Greg, "Era of Short Film Reborn on the Net," *Los Angeles Times*, June 19, 2000, p. A1.

Mirapaul, Matthew, "New York's Chaos Inspires Web Art," *New York Times on the Web*, July 6, 2000.

____, "Getting Tangible Dollars for an Intangible Creation," *New York Times*, February 18, 2002, p. E2.

Morse, Margaret, *Virtualities: Television, Media Arts, and Cyberculture*, Bloomington, IN: Indiana University Press, 1998.

National Alliance for Media Arts and Culture (NAMAC), *A Closer Look: Media Arts 2000*, San Francisco, 2000a.

_____, *Digital Directions: Convergence Planning for the Media Arts*, San Francisco, 2000b.

National Endowment for the Arts (NEA), *Visual Artists in Houston, Minneapolis, Washington, and San Francisco: Earnings and Exhibition Opportunities*, NEA Research Division Report No. 18, Washington, DC: National Endowment for the Arts, 1982.

_____, *1997 Survey of Public Participation in the Arts*, NEA Research Division Report No. 39, Washington, DC: National Endowment for the Arts, 1998a.

_____, *Museums, Arboreta, Botanical Gardens and Zoos Report 18% Growth, 1987–1992*, NEA Research Division Report No. 64, Washington, DC: National Endowment for the Arts, May 1998b.

Rees, A. L., *A History of Experimental Film and Video*, London: BFI, 1999.

Renan, Sheldon, *An Introduction to the American Underground Film*, New York: E.P. Dutton & Co., Inc., 1967.

Renz, Loren, and Steven Lawrence, *Arts Funding: An Update on Foundation Trends*, Third Edition, New York: The Foundation Center, 1998.

Robinson, John P., and Geoffrey Godbey, *Time for Life: The Surprising Ways Americans Use Their Time*, University Park, PA: Pennsylvania State University Press, 1997.

Rockefeller Foundation, *Meeting on New Media Technology and the Arts*, New York, NY, August 17–18, 2001.

Ronfeldt, David, and John Arquilla, "Networks, Netwars, and the Fight for the Future," *First Monday*, June 10, 2001, http://www.firstmonday.dk/issues/issue6_10/ronfeldt/#r1.

Rosenthal, Alan, *The Documentary Conscience*, Berkeley, CA: University of California, 1980.

Rosenthal, Alan, ed., *New Challenges for Documentary*, Berkeley, CA: University of California, 1988.

Roxborough, Scott, "Style Counsel," TheHollywoodReporter.com, March 5–11, 2002, http://www.hollywoodreporter.com.

Rush, Michael, *New Media in Late 20th-Century Art*, London: Thames & Hudson Ltd., 2001.

Ruttenberg, Friedman, Kilgallon, Gutchess & Associates, *Survey of Employment, Underemployment and Unemployment in the Performing Arts*, Human Resources Institute, AFL-CIO, 1977–1978.

Schneider, Ira, and Beryl Korot, eds., *Video Art: An Anthology*, New York: Harcourt, Brace, Jovanovich, 1976.

Schor, Juliet, *The Overworked American: The Unexpected Decline of Leisure*, New York: Basic Books, 1991.

Seid, Steve, "High Wire, No Safety Net," *Art Journal*, Vol. 54, Winter 1995.

Sitney, P. Adams, ed., *Film Culture Reader*, New York: Cooper Square Press, 2000.

Stroud, Michael, "A Music Industry Death Knell?" *Wired*, January 11, 2000.

Throsby, David, and Beverley Thompson, *But What Do You Do for a Living? A New Economic Study of Australian Artists*, Redfern, Australia: Australia Council for the Arts, 1994.

Urice, John K., "The Future of the State Arts Agency Movement in the 1990s: Decline and Effect," *Journal of Arts Management, Law and Society*, Vol. 22, No. 1, Spring 1992, pp. 19–32.

Useem, Michael, "Corporate Support for Culture and the Arts," in Margaret J. Wyszomirski and Pat Clubb, eds., *The Cost of Culture: Patterns and Prospects of Private Arts Patronage*, New York: ACA Books, 1990.

Vogel, Harold L., *Entertainment Industry Economics: A Guide for Financial Analysis*, 4th Edition, Cambridge, UK: Cambridge University Press, 1998.

von Uchtrup, Michael Ward, "Conjuring New Muses," *Art Papers*, Vol. 23, January/February 1999.

Walker, Beverly, and Leonard Klady, "Independent Films at the Box Office," *Film Comment*, Vol. 22, May/June 1986, pp. 61–66.

Youngblood, Gene, *Expanded Cinema*, New York: E.P. Dutton, 1970.